NUDE & BEAUTY PHOTOGRAPHY

Nancy Brown

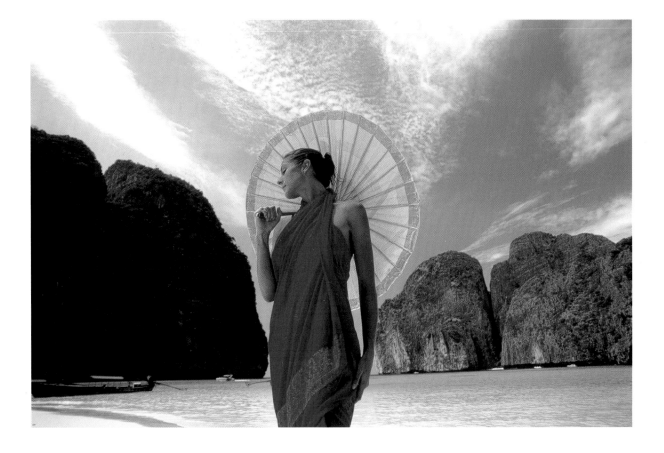

KODAK Pro Workshop Series

Silver Pixel Press®
Rochester, New York

KODAK Pro Workshop Series

NUDE & BEAUTY PHOTOGRAPHY
By Nancy Brown

ISBN 0-87985-774-9
Publication PW-1
Cat. No. E147 5928

Kodak
LICENSED PRODUCT

KODAK is a trademark of Eastman Kodak Company used under license.
EKTACHROME is a trademark of Eastman Kodak Company.

All other product names used in this book are trademarks of their respective owners.

KODAK Books are published under license
from Eastman Kodak Company by
 Silver Pixel Press®
 A Tiffen® Company
 21 Jet View Drive
 Rochester, NY 14624 USA
 Fax: (716) 328-5078
 www.silverpixelpress.com

Library of Congress Cataloging-in-Publication Data

Brown, Nancy.
 Nude & beauty photography / Nancy Brown.
 p. cm. -- (Kodak pro workshop series)
 ISBN 0-87985-774-9 (pbk.)
 1. Photography of the nude--Handbooks, manuals, etc. 2. Glamour
photography--Handbooks, manuals, etc. I. Title: Nude and beauty
photography. II. Title. III. Series.

TR674.B765 2000
778.9'21--dc21

 99-087076

To Jonathan Greene, my studio manager, assistant, and handler of everything!

To Rhona Krauss, my makeup and hair artist—seventeen years of working together and the first one I call when planning a photograph.

To Lisa Heywood, a great model who loves photography and is a good friend.

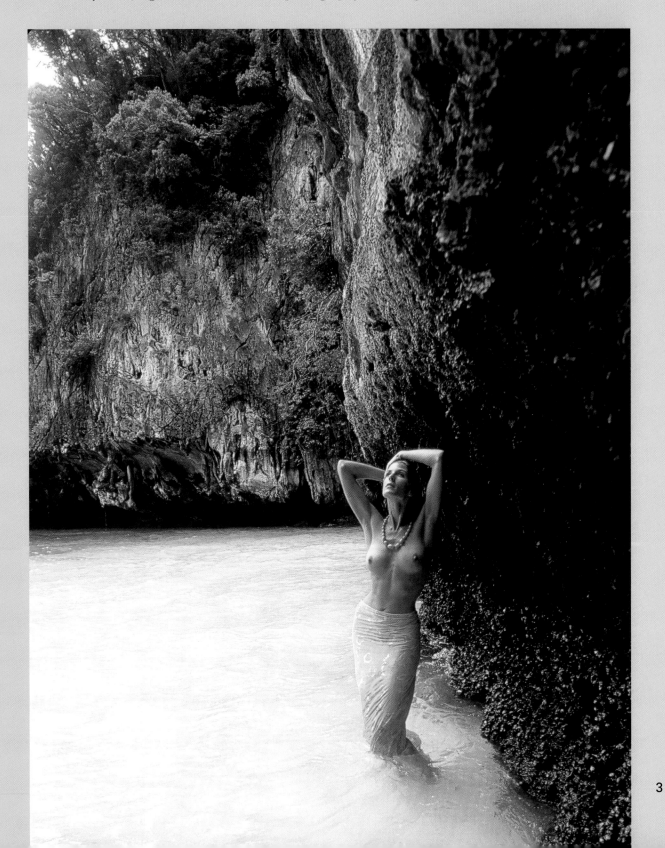

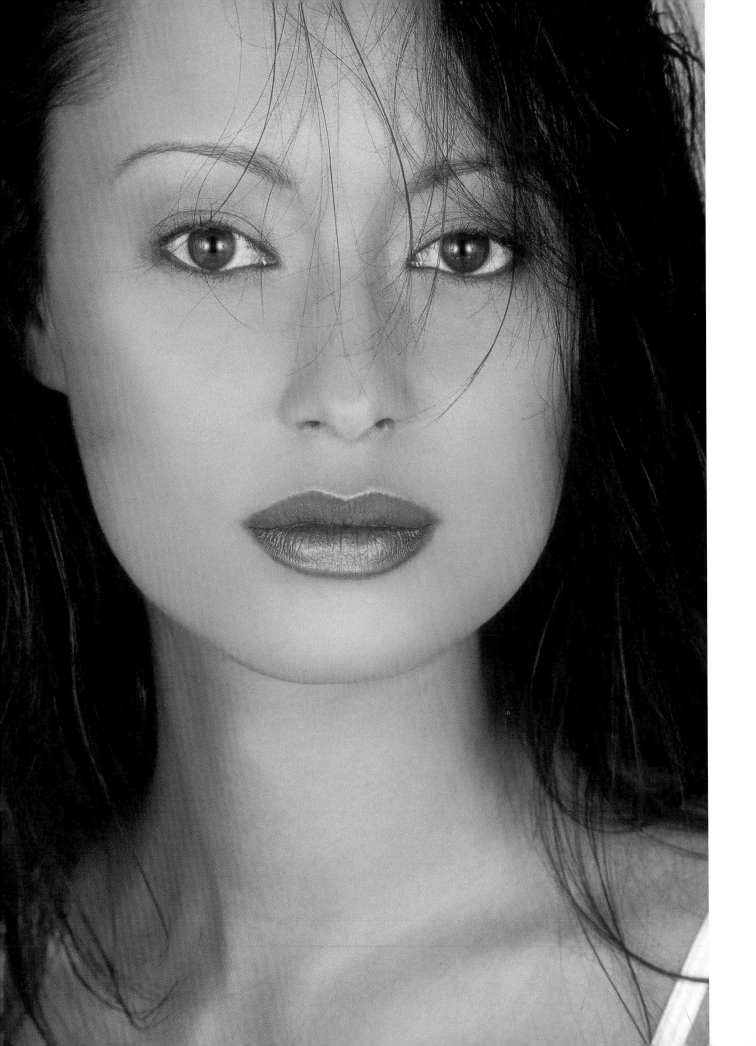

CONTENTS

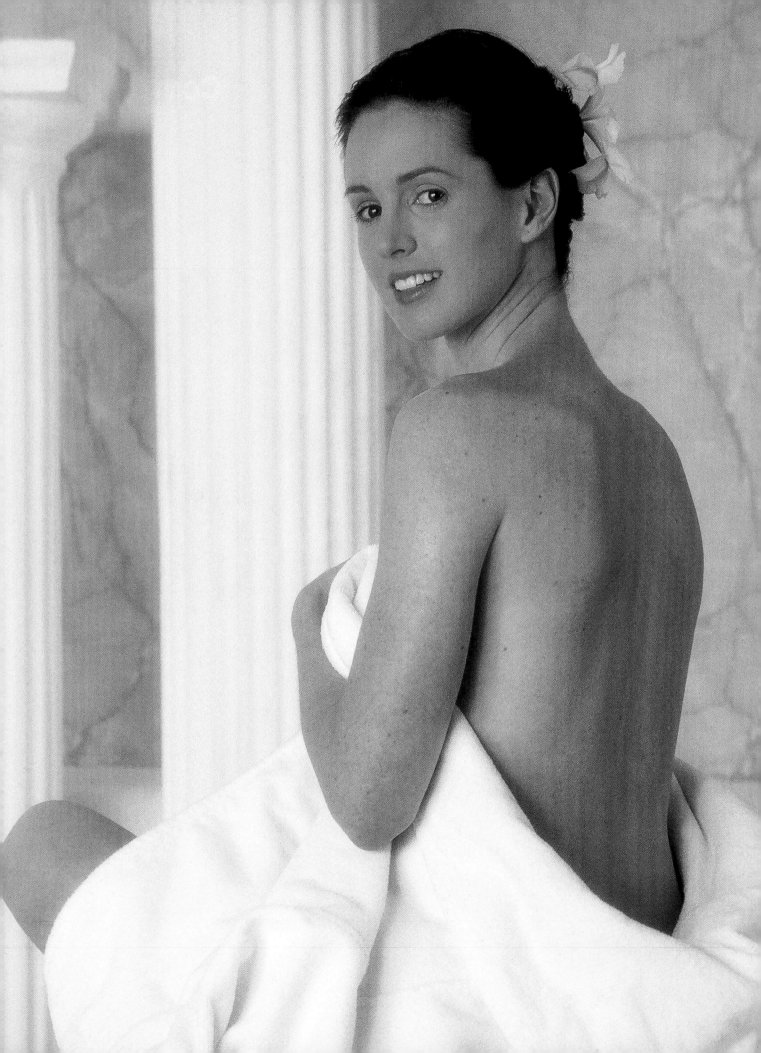

INTRODUCTION

Throughout my career as a photographer, my favorite kind of photography has always been beauty. So when I was asked to do a book on nude photography, my first thought was to do nudes that expressed beauty rather than those that projected a more sexual feeling. ■ The title, *Nude & Beauty Photography*, links my interests very well, especially since "beauty" really is the most important thing I consider when photographing nudes. First and foremost, I have to have *beauty*. Not all photographers of nudes feel the same way. I once had an assistant who later became a professional photographer, and her choices were totally different than mine. She became very successful but with a completely different style: She shot with very hard lighting and used models who were more "realistic" than idealized. She goes for the more gritty look in fashion photography. I don't. I prefer beauty; that's my approach to life. It's what I appreciate and what I like to see, so it's no wonder that this is the kind of photography I do. I didn't have to force myself into this kind of work.

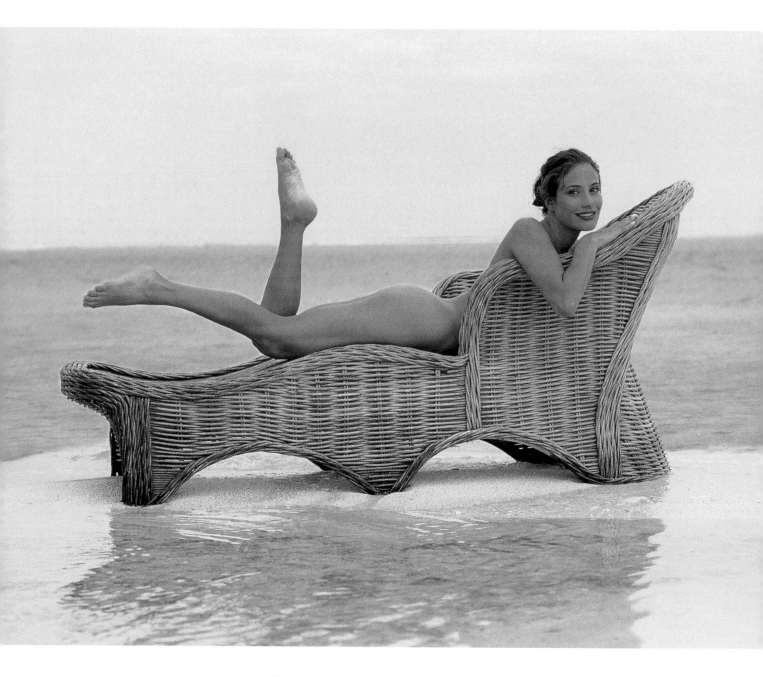

Donna's body language and attitude helped to create a carefree beauty photo. We used a Tiffen 812® warming filter for the shot—that and the light quality give this photo a pastel look, which I love.

When I say "beauty," I mean I have to have models with great
bodies...and greater skin. For other types of photography, I might
use a man or woman who's very commercial, or who has a good
face, or the right face to sell the product. But when I'm photograph-
ing nudes, "a good face" or "the right face" isn't enough: The body
and the skin are the main considerations, and they have to be as
near-perfect as I can get.

That is no guarantee that the model is going to come alive when
the camera is pointed at her. Professional models, sure, they'll give
me everything I need; that's their business. But there are times
when I'll be working with aspiring models or first-timers, and I may
not know what I have until I see the results on film. It has hap-
pened. Someone comes in, and my first impression is that she does-
n't have a great look. I may be doing head shots, a few full-lengths
for a portfolio, or tests for a nude shoot, and early on I don't think
the girl looks that good. But I finish shooting, and when I get the
film back from the lab and onto the light box, wow, all of a sudden I
see that this girl really has something going! She photographed a lot
better than I thought she would; what a surprise!

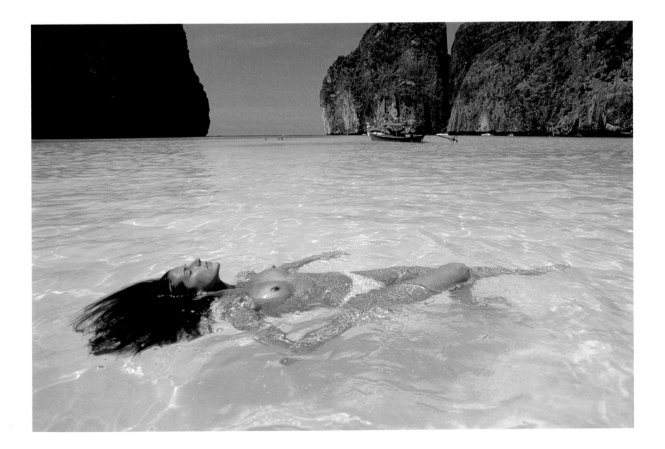

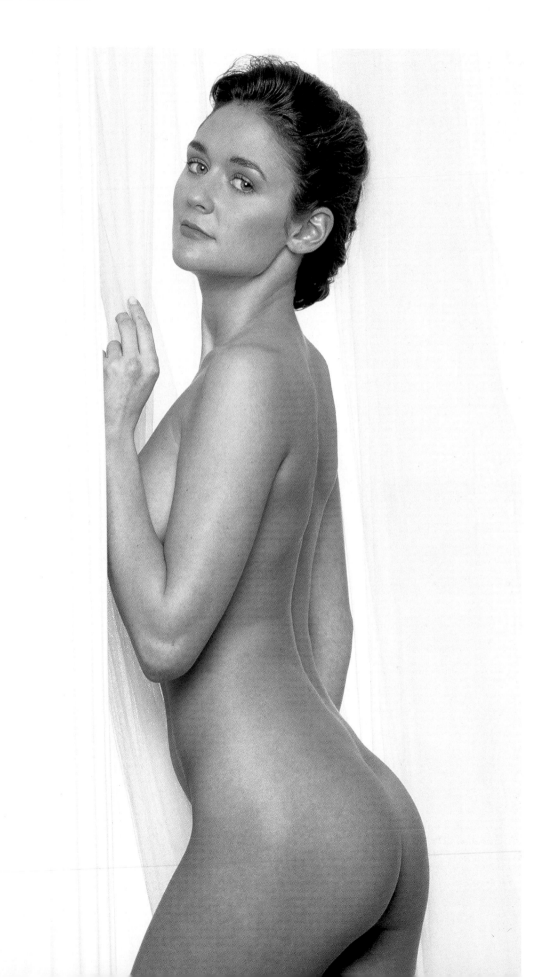

And it's happened the other way around, too, but fortunately, not as often: She's a raving beauty but with dead eyes, no expression. Physically gorgeous, but photographically a zero. What it is is *personality*. Once they get in front of the camera, some models really get going, and some just never come alive. And sometimes I don't see it until I look at the film.

After that, photographing nudes is, frankly, not all that different from any other photographic job: I plan it, I light it, I shoot it.

What follows is a discussion of how I do these things. I think that up to a point, knowing how another photographer does the work is valuable: It's an opportunity to share ideas, concepts, and techniques. It's a chance to solve some problems and learn how to avoid some others. But once you've noted and absorbed what another photographer has to show and tell, it's up to you to put that to use in your own way. Practically nothing you'll hear from me should be considered as rules—they're ideas and suggestions. This is the way I do it. Your ability to use those ideas and learn from them is what will make your photography *yours*.

I hope you'll be inspired by what you read and see here.

What makes a great beauty shot? Models with great bodies and greater skin. This photo is ideal as a stock shot that says "clean and wholesome."

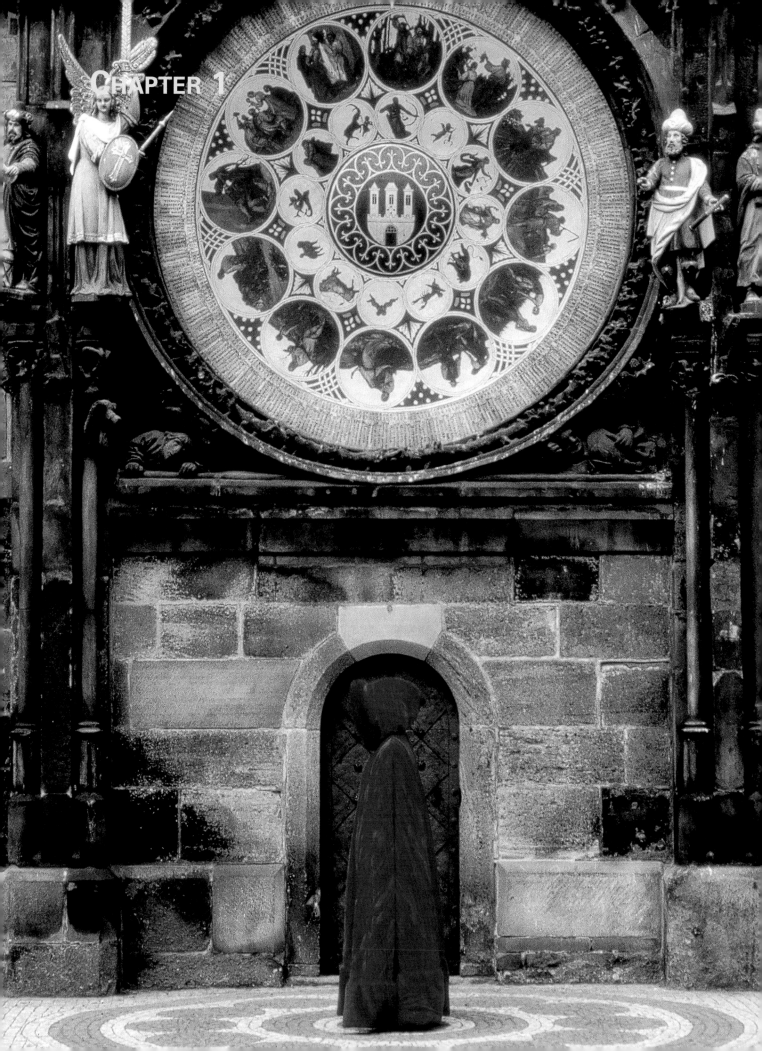

IMAGINING THE NUDE

The photo is in my head first. ■ It exists before anything else—before the model is hired, before the location is chosen, and certainly before any shooting takes place. Most often I come up with a concept—the idea, the motivation of the picture—and then I do whatever it takes with casting, props, location, and technique to get that idea onto the film. ■ Somebody once asked me where the concepts came from. I remember saying, "Probably just from the world." By that I meant from *everything*. From movies, from magazines, from other photographs that I've seen and stored in my memory. ■ The photographer is an observer. At least, he or she better be. If you're not, you're going to miss out on a lot of ideas and opportunities.

Inspiration

Sometimes a photograph—or, for that matter, an entire shoot—can be inspired by a single element. I went on location to Prague once, and the entire trip was based on a prop. It was an article of clothing—a cape. I had done a photo one time of a girl in a cape, and it looked good. And I'd been doing photographs like that off and on for years, and it was time again to pursue the idea, the concept, with a different model and in a different location to see how far I could take it this time. Everything started with that one element, the cape. Very often my photographs begin with me saying to myself, "Let me see what I can do with this. Or let me see what *more* I can do with this."

Ideas come from everywhere, from whatever goes into my head. I keep a mental wish list, and I take it into the studio and on location.

I love to look through magazines; I consider it part of my job. I'll look through all types: fashion, lifestyle, fitness, anything. Most of the time I'll go through them really fast, looking for an image or an idea that will stop me cold. I tear out pages with pictures I like. Sometimes I won't pull anything, but usually I see at least one or two things that I want to remember. Some of the pictures are in ads, some appear in editorial illustrations. Maybe there will be just one thing in the picture that interests me, but it's that one thing that will stop me...and inspire me. It will suggest all kinds of possibilities. I saw a shot of a girl in a leotard with a towel around her neck, a picture that anyone could take, certainly not "a stopper." But here's what made it special and what stopped me—she was laughing, and she was holding an apple. The laugh and the prop made it memorable to me. I realized it was a great stock shot. I'm not going to copy it; that's not what I'm looking for. But I'm going to allow myself to be inspired. So now I have to remember: The girl in the leotard with the towel, that's pretty standard, but the apple and the laughing are really what made the picture.

I tear out pages like that, and I keep them in a special binder. Then when I'm ready to work with a model, if I don't have a special idea for the shoot, I'll either remember something I saw or I'll take a look in the binder.

My photography of nudes frequently works that way. I'm always pulling out great nude shots—they're always interesting. Then if I need ideas, I look through those clippings and magazine pages. I'm looking to see what I can do, how I can interpret something. It's not copying, it's inspiration.

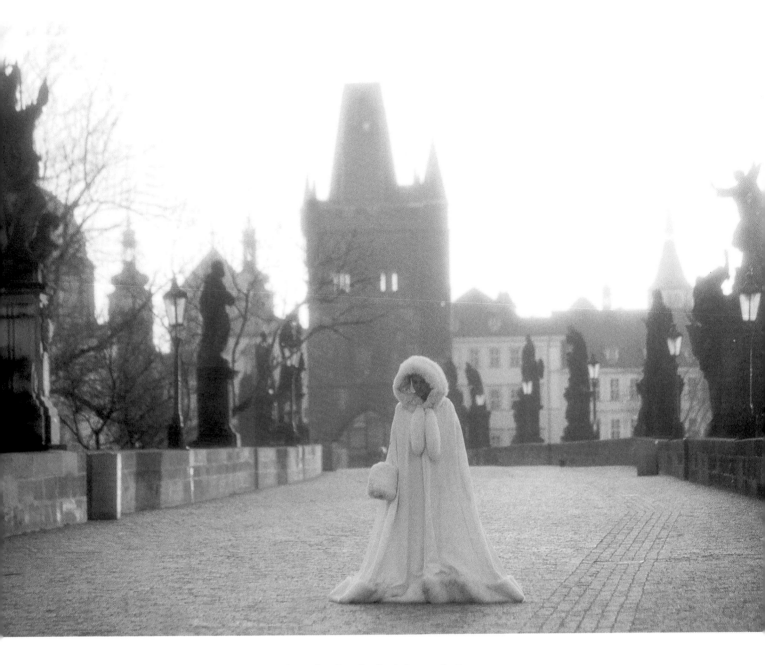

I brought capes to Prague, because I thought the city had the perfect complementary atmosphere of style and mystery. I'll be traveling with capes again soon, perhaps to Bavaria or to other locations in Eastern Europe.

The Client's Input

Of course when I'm shooting an assignment, the concepts come from the client. And not only the concepts, but also the location, the model, even the type of lighting. If it's a location shoot, I'll scout the location days ahead so I'll know what I'm dealing with, but the choice of that location and the look of the photograph comes from the person who's paying the bills. And if my idea of the shot doesn't coincide with theirs, even if I'm sure I could do it better, I have to do it their way.

I once did a great picture for Maybelline cosmetics—a girl on a swing, taken in the studio with a beautiful painted background that we had specially made. The picture was beautiful. At one point the client had a 16 x 20-inch print on a desk in one of the corporate offices. The image was all set to go into print, and a secretary walked by and said, "My gosh, it looks just like a painting. It doesn't look real." Right then, everything changed. We had to go out on location and shoot the setup under a real tree. They paid for the whole thing over again. Fine, that's their privilege, but in my opinion, the picture we took outside under the tree wasn't even close to the beauty of the shot we got in the studio. I didn't even put the location shot in my portfolio.

If you have a good relationship with the client or if you instinctively feel that the client trusts you, what you try to do is get a few shots the way *you* see it. You do exactly what the art director wants, and you do a damn good job of it, and then you say, "Hey, let me try something...I have an idea." Everybody does that—if there's time to do it—and if you're working with a good art director or one who knows your track record, he'll give you a shot at it.

The best situation is when the client hires me for my ideas. Perhaps it's someone I've worked with for a long time or someone who specifically wants what I do best. I shot for Maidenform for five years and worked with an art director who'd essentially pick the lingerie we had to shoot and then let me work with it and the models. That's not the way it usually works when you shoot for advertising, and in a way, having the shot laid out for you is a good thing. It's good to have the experience of working according to someone else's plan. It's good discipline—it teaches you what you need to get the photograph. And it's an insight as to what's going on in the business.

The discipline and experience of shooting for a client pays off in confidence when I'm shooting for myself, for stock, or for a model's portfolio. I have to go into the shoot with a pretty clear idea of what I want. And I have to be confident that I'll get it. Let me tell you—without confidence, no one goes to Prague with a model and a trunk full of multicolored capes!

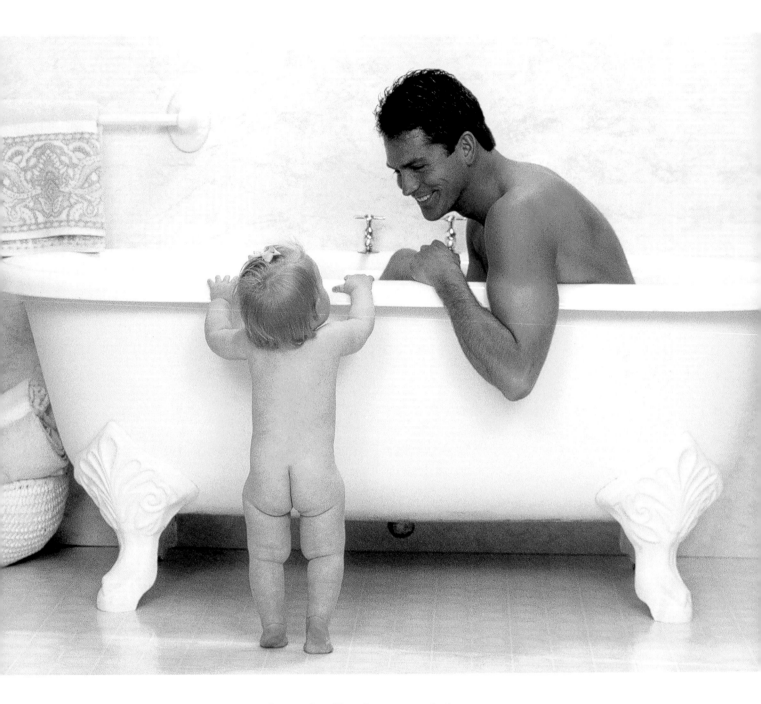

Sometimes you just go with what's happening. The plan was to photograph the baby in the tub, but she didn't want to go. Little by little, she became more interested, and I got this great photograph.

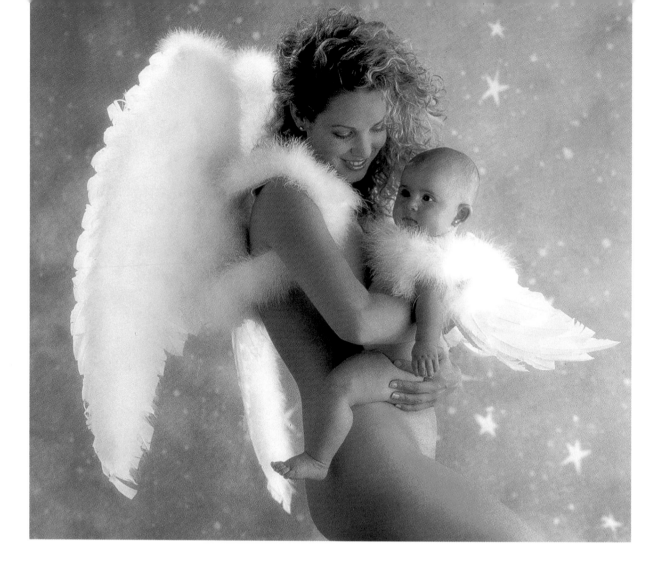

Often I will build a photograph around a prop. For this book, I was looking for something feminine and pretty. Sometimes my choice of prop will be affected by what's fashionable and what's selling at the time, like wings. Lisa, the model, told me her friend had beautiful wings at her antique clothing store, and we planned a studio session around them.

Stay Flexible

Of course, what often happens when I go into a shoot with a concept in mind is that I find something better than I had planned. Perhaps there's a great location, or the weather gives me something unexpected to work with. I always stay flexible, and I've learned over the years how to work with the unexpected, often coming up with a better photograph. I once did a shot of a man in a bathtub, and the idea was to photograph a baby in the tub with him. But the baby didn't want to stay in the tub. So we set up with the baby on the outside of the tub and then waited to see what the baby would do. Sure enough, before long the baby wanted to get into the tub, and we got the picture.

Say a model comes in, and for whatever reason, she just doesn't look her best that day. Now I have to make some changes in make-up, lighting, or the angle of the shot. Or I get a model in for a nude shoot and find that she's just not comfortable. I might go for a partially nude look, try to talk her into being comfortable, or give her a prop that works to conceal her a bit. No matter what I try, I have to try *something*, because in a case like this, the original plan is going to have to be revised.

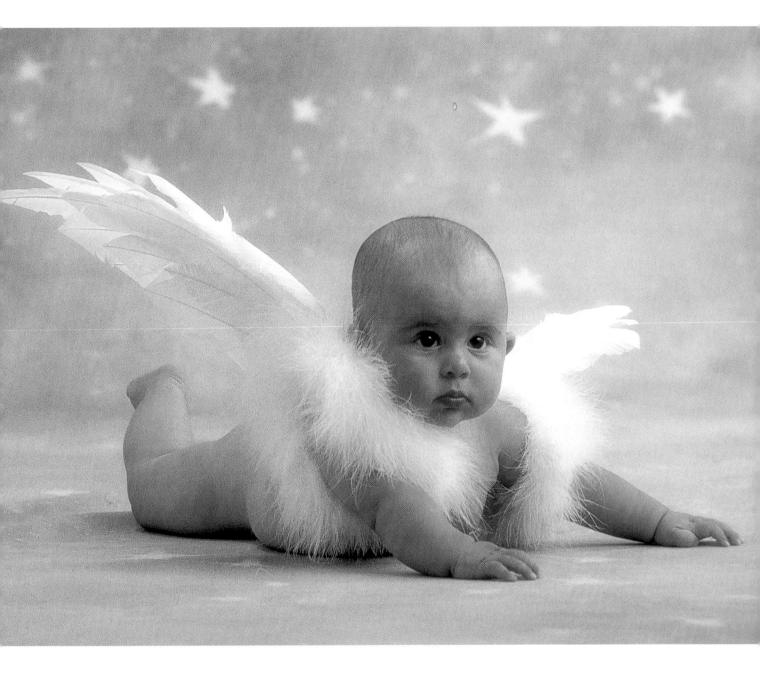

After deciding on wings for the shoot, the real bonus was that we found small wings, too, for my makeup artist's baby.

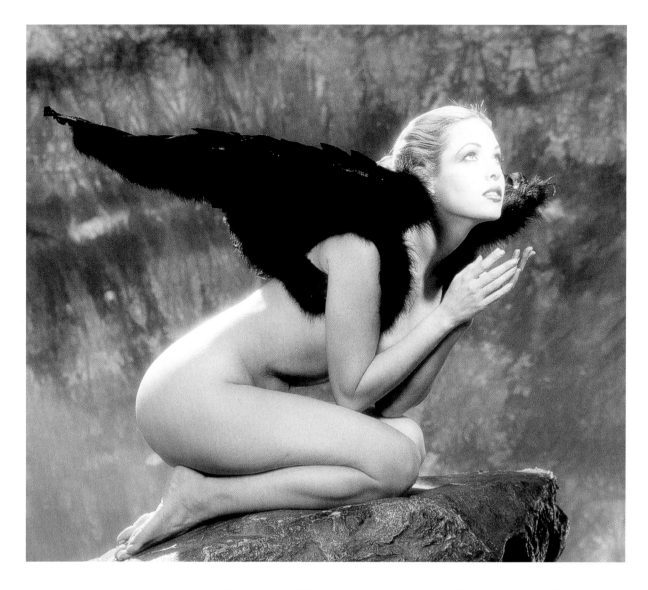

Same idea—wings—but with a very different feeling. The photos with white wings are very high-key, very ethereal. For a different look, we got black wings and a painted background, and I lit the set for high contrast. In black and white, the photo seems much harder and more dramatic.

The same holds true for equipment and for mechanical problems. Say for some unforeseen reason a strobe's power pack goes down, and I have only two packs with me. Well, I change the lighting so I can work the shot with only one pack.

If you don't have that kind of flexibility, and if you can't think on your feet that way, you're going to make yourself miserable. I like to think that if these unexpected things happen, it's for a very good reason. So I make the changes and make do with what I have.

But—and I have to emphasize this—I always begin with an idea, a plan. Before the image ever exists on film, it exists in my head. That's how I start.

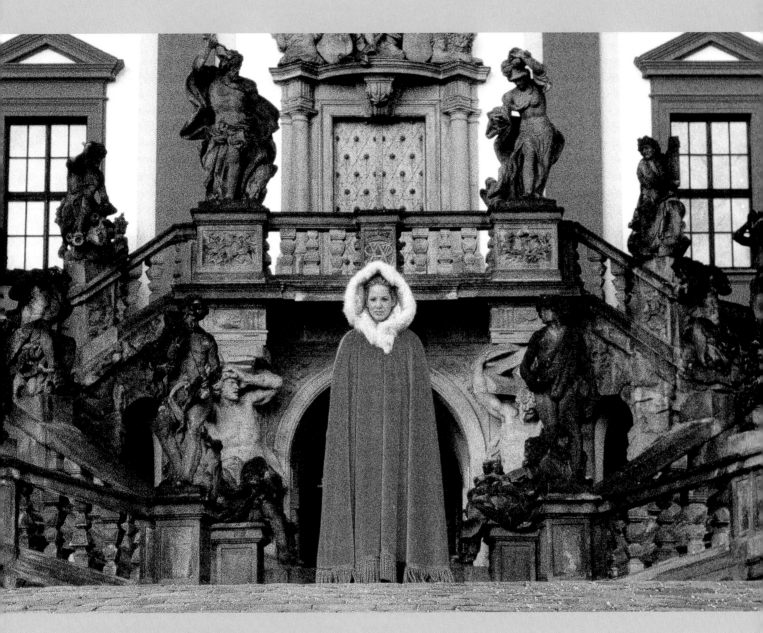

The Prague Caper

For a few years now I've been taking pictures of models in capes, with an eye to someday producing a calendar illustrated with cape photographs. I haven't been rushing it, just pretty much shooting as I go. On a stock assignment, I might take a cape along and add a few photos to the collection. I did just that on a recent trip to Thailand, making a photograph of a model wearing a cape, perched on the back of an elephant. In a sense I've come to think of capes as equipment that I'll take along to see if an opportunity arises to make use of them.

The photographs you see here were taken in Prague, a city I visited for the most basic of reasons: I wanted to see it. And of course, I thought it would be a great place to take photographs. Judging from the pictures I'd seen of Prague, it looked absolutely ideal for photography and certainly was a city with many perfect backgrounds for photographs of a model in a cape. Prague has a lot of beautiful architecture and a certain romantic, timeless look. And a bit of a look of mystery, too, which fits right into my feelings about capes. They're mysterious items, certainly not typical articles of clothing. Today capes are costumes; you usually see them in movies, on Broadway, or in old photos.

I think my fascination with capes as clothing props began years ago when I did a photo of a model wearing a red cape at Westbury Gardens on Long Island. The photo of the model positioned between two trees and wearing a cape had such a great look and provoked such strong reactions that I used it as a promotional card. It was a real attention-getter. Some people saw a Little Red Riding Hood figure in a peaceful garden; to others it was very eerie—a mysterious figure in a cape in the forest. In any case, I knew I was onto something with capes.

I went to Prague with only one model. I deliberately decided not to take two models, as I didn't want to do stock photos of Prague as a commercial, tourist-attraction city. I took with me three elegant, colorful capes that were specially made for me. Two of them were reversible, so I had even more colors to work with.

I rented a car and scouted around for locations for a few days. Then I drove back to the places I'd noted and did the shooting. In one way I was very fortunate: I got the kind of overcast, gray days that added so much atmosphere and drama to the photographs (I'd deliberately scheduled the trip for winter). On the other hand, I didn't get the snow that I'd hoped for.

In a few cases we got extraordinarily lucky and found old mansions and castles featuring painted trim that closely matched the colors of the capes. It looked like the capes belonged there, and the interplay of color, texture, and mood was perfect. I couldn't have planned it better.

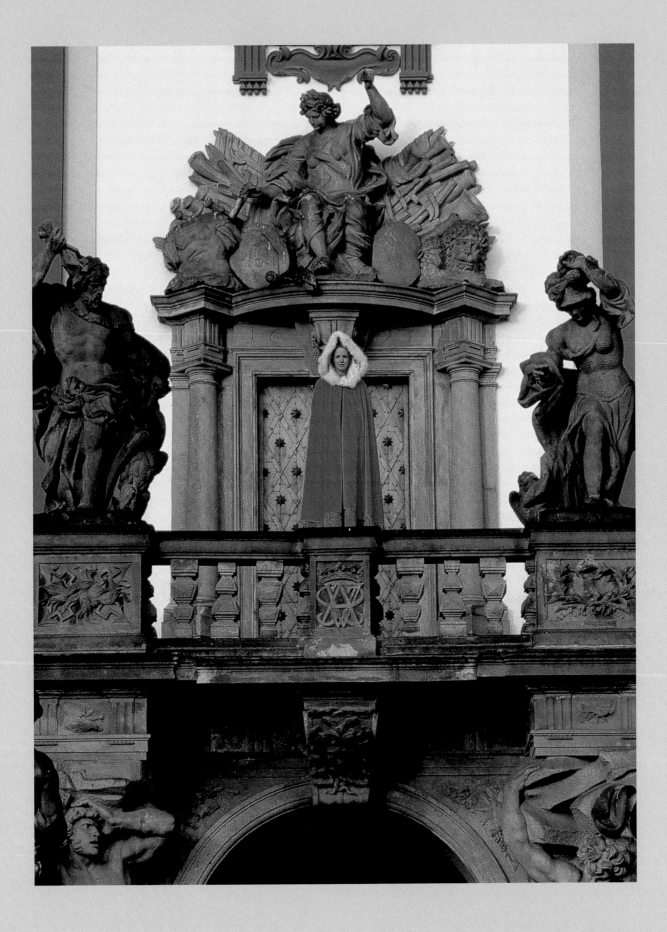

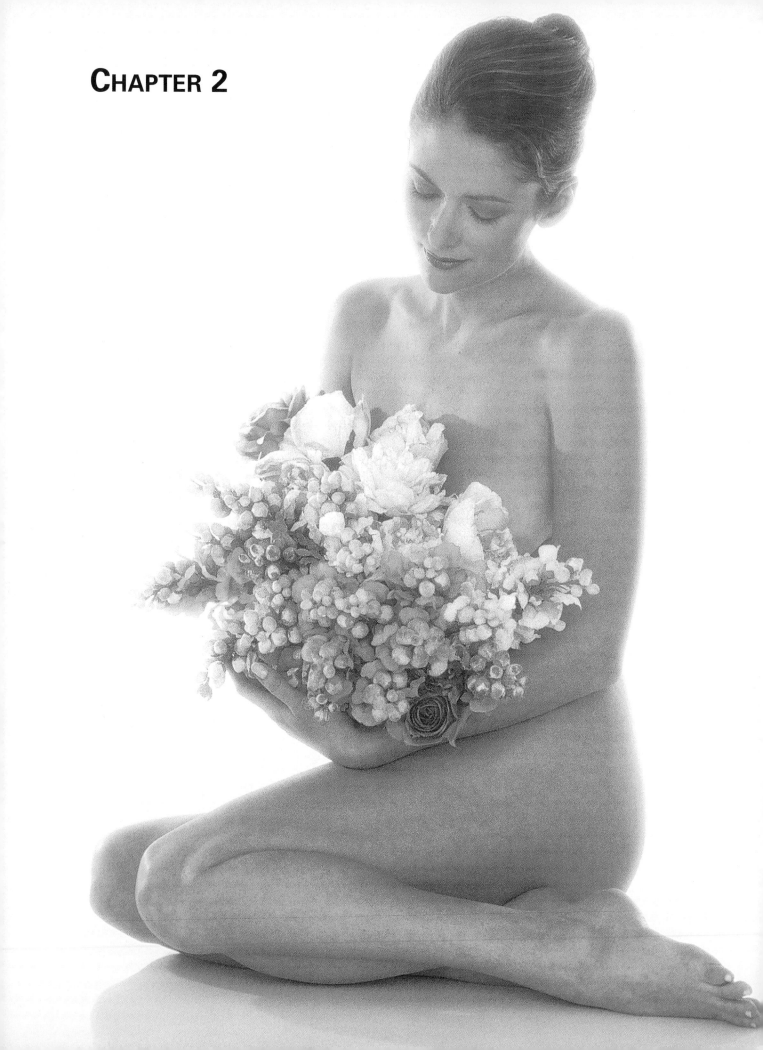

CHAPTER 2

THE IMPLIED NUDE

Today in our society there's so much nudity that it's almost an accepted standard and consequently, easier for photographers to create and sell nude photos. Even the big-name supermodels are posing nude. ■ Before I became a photographer, I was a model, and in one instance my husband, my children, and I did some photographs for a pharmaceutical company in which we were seen nude from the back—I think it was for a study of family body types. ■ In the era in which I modeled, nudity was a whole different ball game. None of the models I worked with in those days ever did nudes. Even the women in *Playboy* magazine layouts were shown in a more conservative way than they are today. And when I was modeling, if a girl posed for *Playboy*, advertising firms representing large corporations wouldn't cast her. Nowadays, it pretty much doesn't matter; nudity is more accepted. ■ One of the models I photograph the most does a lot of nude modeling, and she does other types of modeling as well. Her nude work doesn't seem to affect whatever else she does, and she certainly doesn't have to hide the fact that she's done nude modeling. Even on her composites, she'll display a very provocative shot.

A photograph of the
model from the back
gives just the suggestion
of nudity.

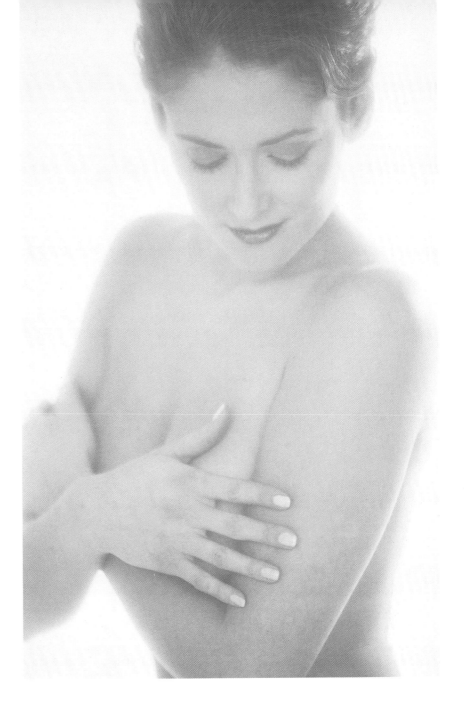

A photograph that implies nudity can be even more interesting and attractive than one that is explicit. Here I used filters for a soft, sexy look.

The Suggestion of Nudity

To me, the fact that nudity is much more prevalent and accepted today means that a photograph that *implies* or suggests nudity can be even more interesting and attractive than one that is explicit. Even more beautiful.

It's like in the old-time movies: The filmmakers weren't permitted to show a lot, so they left a lot to your imagination. Instead of blatantly revealing everything on the screen, they suggested, they implied. They allowed you to imagine what was going on, to visualize in your mind what you weren't seeing. Personally, I think that can be a lot more enticing. A little less is sometimes a lot better, and that's something I think about whenever I'm photographing nudes.

Sometimes models don't want to pose totally nude. You can solve that problem with a prop, such as a sheet or a towel. The result in this photo is a sexy image without any overt nudity.

I wanted the lighting to feel like morning sun streaming through a window, and I chose a redheaded model, Lyndi, to keep everything in the same tones. To cast subtle shadows and diffuse the light a little, a venetian blind held up with four autopoles is positioned horizontally over the bed. Three lights directed down through the blinds are used to illuminate the model. The center light is gelled to 3800°K to give the photo a warm glow. Two lights at floor level provide fill. The camera is positioned very high to get the view from above.

"Near Nude"

And I'm not the only one who thinks that—just look around. You see degrees of nudity in lots of ads. Models are partially nude everywhere—on magazine pages, billboards, even in some television advertising.

As a practical matter, sometimes "near nude" may be the way to go if for whatever reason your model isn't as absolutely physically perfect as you'd like. You can use a towel, a prop, or an article of clothing with a model who has a few problems. And it's happened that I've worked with models who were beautiful, absolutely perfect for nude photography, but who just didn't want to be totally nude. So within the same idea, the same set, and maybe working with the same props, we did something with a sheet or towel, lighting, or angle, and we got around it. Perhaps I photographed her from the back, nude from the waist up. It seemed to work. It had the right feeling; enough was showing, but not everything.

Sometimes the prop will dictate the degree of nudity. There are times when the prop, whatever it is, just won't look right unless it's covering part of the model's body. And many times the way a piece of clothing is draped, the mood it creates, gives the feeling of nudity without the model being nude. I can create that by showing a lot of skin and letting the model's attitude convey the rest.

There are instances when a photographer can end up shooting both ways: implied and slightly more explicit. If I'm sending my portfolio book to, say, a cosmetics company, it may not be appropriate to show nudes. And different markets have different needs and standards: In Europe, they tend to be a bit more freewheeling than in the United States. So if I'm on location or in the studio with a beautiful model who will do nude photography, why waste the opportunity? I've done location shooting where I'll do a set of photographs of the model nude, then a set in which she's wearing a tiny bikini. Now I have photographs for several purposes and markets.

Generally, though, I think that less is more, and a photograph that suggests nudity is much more sensual than one that shows it.

Make Some Changes!

Often the simplest changes can have the most dramatic effect. To create this photo and the one on the next page, the only changes made were the drape of the fabric and the color of the background. Switching from a black to a white background accentuates the contrast in the lighting. Against the dark background, the glossy highlights on the model's skin give her form a more three–dimensional or sculptural appearance. This gives the model a more assertive character, while the model against the white background appears more passive. In addition, rearranging her gold drape creates a "V" shape that is repeated in the way the model is holding her arms. These strong diagonals make for a more dynamic composition. Same model, same lighting, but amazingly you get two different images with just two simple changes.

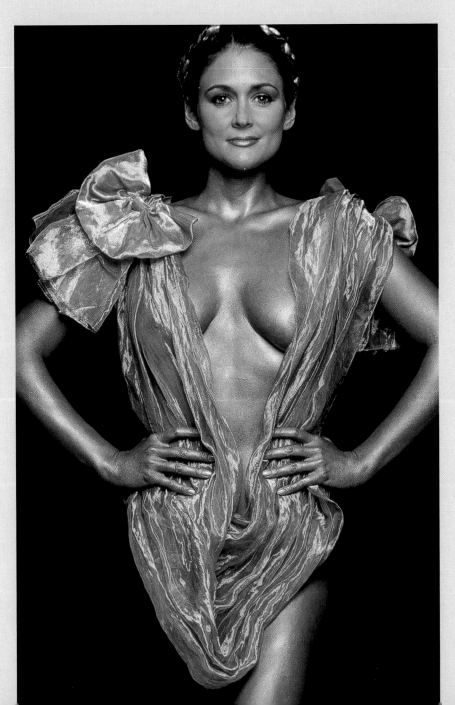

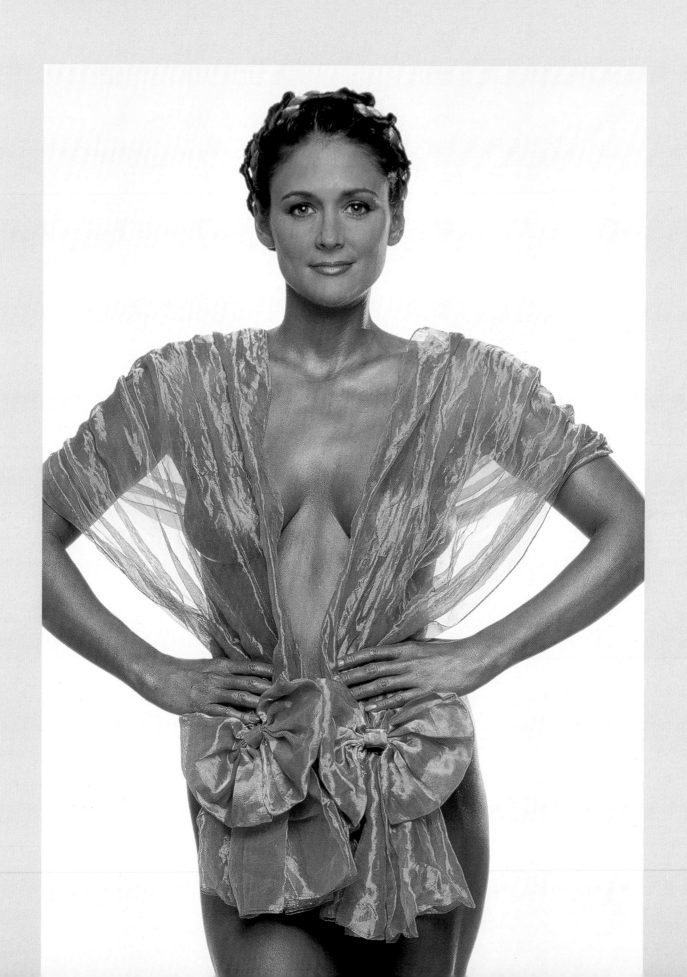

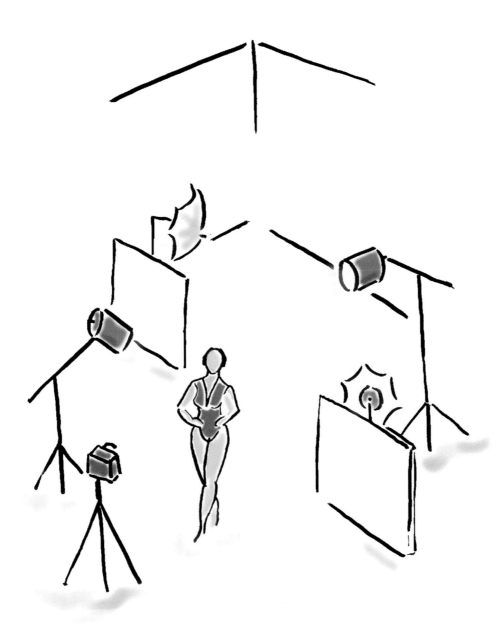

This scarf caught my eye on a sale rack—the best thing about it is its shine. The main light on Lisa comes from a large Mola strobe head on a boom arm. There is also a hairlight—a small Mola head on a boom arm—positioned behind the model. This helps separate the model from the background. Umbrellas bounce light from two strobes onto the background. Flats are set up to prevent the light from spilling onto the model.

CHAPTER 3

WORKING WITH MODELS

The first thing, of course, is a model's looks: great skin, great face, great features, great body. And then personality kicks in: If a model is mind-bogglingly beautiful but has a bad attitude, forget it. Personality is such a big part of working with models, it's the reason why I use the same people over and over. Simply, they are great to work with, meaning they work with me to get the photographs. ■ By attitude I don't mean that the model will necessarily be hard to direct. After all, models show up to be photographed; that's their business. It's just that some with a bad attitude think that being difficult is the way they're supposed to act, that being a model *means* being difficult. ■ Good models are intelligent, they have common sense, and often they have a sixth sense. When I put them on the set, I don't have to tell them everything that they should do. Because they are bright, they understand the mood of the photo and get into—and contribute to—what's going on.

The longer you're going to work with a model—say, a few days or a week on location—the more important it is that you know the person. Some photographers have a checklist of questions they'll ask, and to a certain extent I do that, too, in order to find out what the model is comfortable with. But most of it is very simple: I either like them or I don't, they either have it or they don't. It's personality, intelligence, and the willingness to work. You have to be intuitive and a good judge of people. I can usually tell when a model first comes in if there's going to be trouble. Over the years, I haven't had many problems.

When I'm working for a client, he'll make the final decision on the model. I'll do a casting session, shoot a series of prints on Polaroid film, and hand them in. I may get to comment on the models I like, but the decision is up to the client. If he happens to choose a model who turns out to be difficult to work with, I have to be prepared to make the best of it to get the job done.

Good models often have a sixth sense about posing. They understand gesture and form, and with a little direction, can usually give you the look you are trying to achieve.

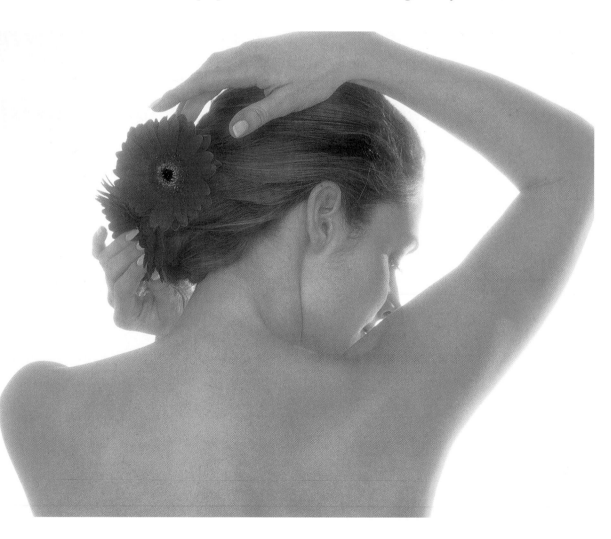

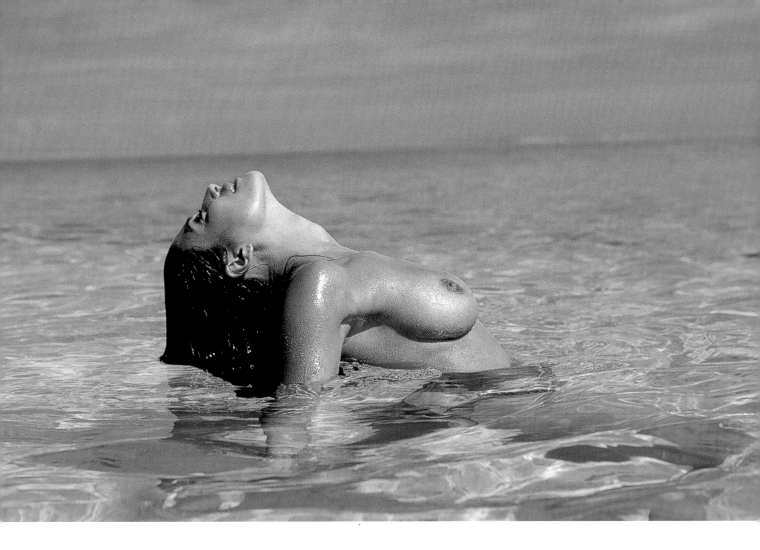

What happens more frequently than working with a difficult model is working with one who doesn't have that much experience. There's one agent I use occasionally who represents models who have little or no experience, and we run into fear, shyness, or just not knowing what to do. The truth is, if they are really good-looking, I might try to work with them for a while, but if they're not, I don't even bother. I know it may sound harsh, but I'm here to get the shot, and I have to do my job.

There are things I can do to put a beginner at ease. First, I keep talking. I show her that I'm just a person, too, someone who's going to work with her to get what we want. Very often I find that once she's had her makeup done, she feels better because she looks better. Now she has some confidence. After that, all I can do is start to work with her, and if it goes nowhere, then it's, "Thank you very much and good-bye."

I don't like to take nude photographs of a model I don't know—one I haven't worked with before or one who doesn't come highly recommended by an agent I trust. If you find yourself in this situation, I suggest you do some work ahead of time. Meet with her, talk with her, and get a feel for what she's all about. If she has pictures, of course look at them. What you don't want is any kind of surprise when you get on the set and are ready to shoot.

Donna had never done nude modeling before the trip to Bora Bora, but after the first couple of shots, she was fine. The beaches there are full of nude sunbathers, so the atmosphere was comfortable.

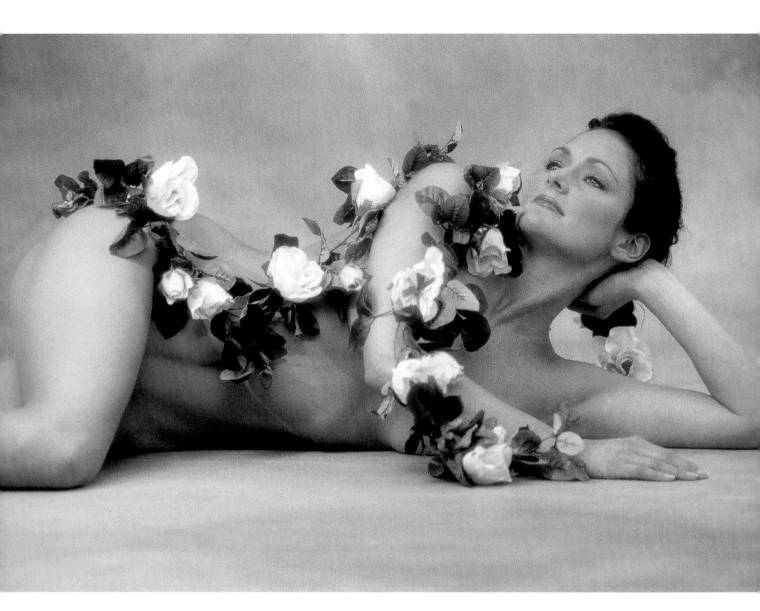

When Lisa put her head back with a dreamy look in her eyes, she hit the mood I was going for perfectly.

Know the Rules

So, if there are rules to this game, rule number two is this: Tell her what you are going to be doing! (Rule number one? Never touch!) She doesn't want any surprises, either. You want her to know exactly what you have in mind for this shooting session, even if she's done nude modeling before. It's going to be a very bad scene if you're planning to do nude shooting and you didn't tell the model. If you tell her to drop the towel and she doesn't want to, you have a problem.

Remember, too, that just telling the model you're going to be doing nude photography isn't enough. This also goes for models you've worked with before. Talk about what the setup is going to be and that the set will be private; there won't be a lot of people walking in and out. I normally keep the studio door open when I'm

shooting, but on a set where I'm shooting nude photos, the door is locked. Someone who wants to come in has to ring and wait. It's just respectful of the talent to do it that way. It really doesn't matter to some models, but others may be very uncomfortable with an open set. You have to show that you're considerate of them in that situation. And after a while, models you work with regularly will know how you do things; they'll know what to expect on your set. Which, by the way, is why it pays to have a good reputation. What counts for a model—good attitude, respect, and intelligence—counts for a photographer as well.

Problem Solving

I've heard photographers say that being a photographer is synonymous with being a problem solver, and although you don't want to spend all of your time doing that, it's the truth. Working with models can often mean working through problems.

The placement of the model's arms helped keep this photo more commercial and not so explicit. Experienced models can help you with this.

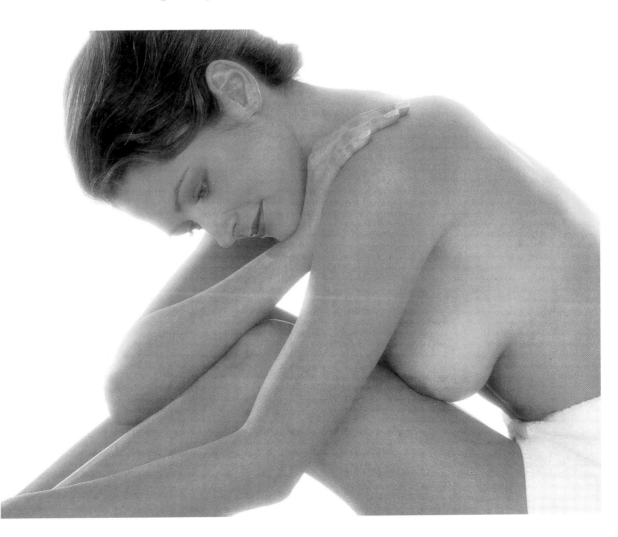

Years ago I shot for *Playboy*, and I never saw the models before they showed up. It was wonderful when I had a beauty! But a lot of times their faces weren't that great, and the face is, obviously, very important. But at *Playboy* I had to use soft-focus filters, so I could generally take care of the less-than-perfect face with relative ease.

Other problems weren't so easy to solve. I remember photographing a model for *Playboy* who had a gorgeous face and a gorgeous body, but she had had breast implants. She had then lost so much weight that her breasts looked like doughnuts. I was stuck. I was doing an assignment for the magazine, she was booked for the whole day, and I had to photograph her. I tried posing her at angles, shooting from the side....not great. Then I had her lie down, and I got some shots at weird angles that seemed to work. Then I put her in a wet suit and zipped it so she was partially covered. I gave her cleavage and made her look sexy! I photographed her from the back, and that also worked.

Also at *Playboy*, I had a model come in who had the implant surgery stitches still in her. They were black stitches, and I wondered, "What is she thinking?" But I had her put her arms around her chest and do some other things so the stitches wouldn't show. I shot from a high angle, and from the back, and took a lot of shots with her lying down. It came out okay, but the magazine still had to retouch several of the photographs.

There are other, less extreme examples, but each one presents a situation the photographer has to work through. A model who's a bit overweight can be draped, covered, or turned a certain way but never shot anywhere near straight on. Fabrics and the model's arms can be used to hide defects. The models can help you: The experienced ones will know, for instance, just how to stand to correct hips that they know are a little too wide.

Before I became a photographer, I was a model, so I know how it feels to be in front of the camera, and I remember the things I didn't like and the things I appreciated. I didn't like people moving my head, and so I never do it now. I'll suggest, "Look up and to the right a bit." And I always appreciated the positive suggestion rather than the criticism. The result is the same, but it's all in the way you say it. Instead of, "No, don't do that," I always say, "Let's try this."

As a model I hated it when the photographer was disorganized. I'd walk into studios that were in chaos—the background wasn't up, the lights weren't in position, people were running around, and the client was standing there waiting. It wasn't a good atmosphere.

One of the photographers I used to work for had a favorite line to cover any number of problems: "Don't worry, we'll retouch it." He moved fast—he was, in fact, well known for getting the job done quickly—but he had no finesse. Other photographers tended to give too many instructions as if they had to demonstrate that they had a lot of ideas and were in total control. I direct my models, but I know enough not to try to overcontrol the situation.

The next is perhaps a subtle point. When I was a model, I could always sense when a photographer was enjoying his job, when it was not considered a chore. And I liked working with those photographers. I think models give their best when there's a sense of enjoyment, even of fun, in the room. You can't always get it, but I remember how important it was.

The other things are pure common sense: a clean, warm, comfortable studio. And one that's light—as a model I always hated it when a studio was a dark hole. I'd be there all day and couldn't see the sun. I think a light, bright, sunny space gives people a positive attitude.

My photos are like that: bright and clean. It's the way I like things and the way I see things. That's my style. I think the personality of the photographer comes out not only in the photographs, but also in the studio. And certainly in the way he or she deals with models.

It's wonderful when photographers and their models have a great rapport with one another. Lyndi, a model I've photographed many times, wanted to have photos of her taken during her pregnancy, and she felt so comfortable with us that I was more than happy to oblige.

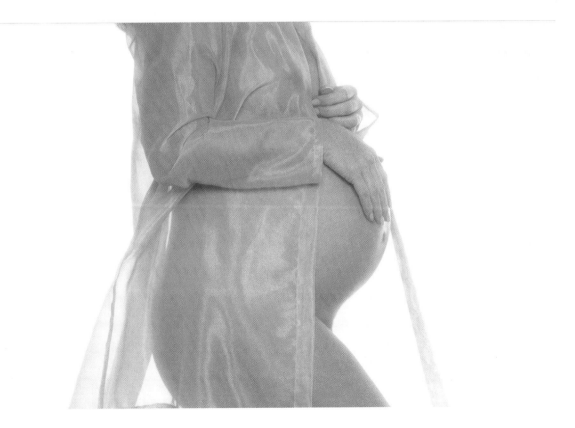

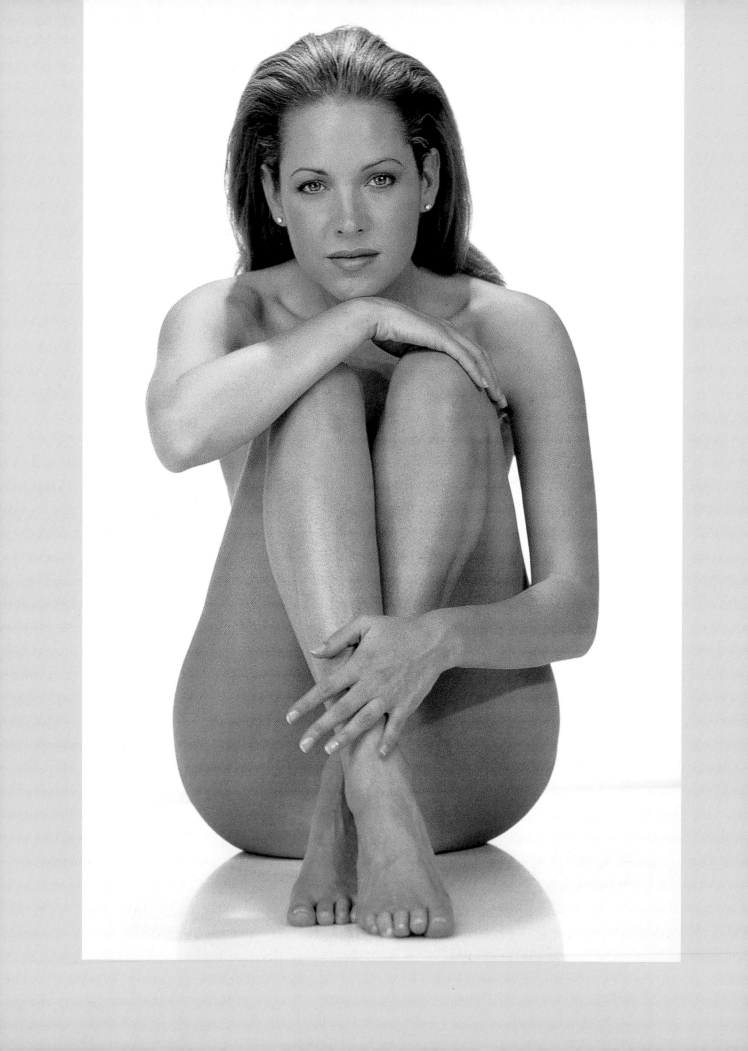

A Model's Notes

I've worked with Lisa Heywood for close to six years on a number of projects and assignments. For a model's perspective on nude and beauty photography, the editors of this book asked Lisa for her comments. —Nancy Brown

"I met Nancy in the summer of 1994. I had just started modeling, and I was with an agency that had really sexy girls who were considered *Playboy*-type girls. I can go in that direction, but I can also do the girl-next-door type of photo. The project was *Playboy's Book of Lingerie*. I had heard Nancy's name mentioned many times. People said, 'She's really nice to work with, and she does great pictures.' And that's how it was. I remember she came around while I was getting my makeup done, and she said, 'Oh, you're very pretty,' so I felt good right from the beginning.

"A lot of people wonder if a female model feels more comfortable working with a female photographer, but to me it's not so much whether the photographer is a man or a woman, it's really all about the personality of the photographer. But because this was the first shoot I'd done for *Playboy*, and I had just started modeling full-time, it probably was good that the photographer was a woman, and that it was Nancy. Because she's a former model, she always thinks about the shoot from the model's point of view. She makes sure that we have what we need, that we're covered in some way when we're not shooting, and that we feel comfortable. And if I have an idea, something I think will work, she'll always say, 'Oh, absolutely, we can try that.' She is extremely open and easy to work with in that respect.

"Frankly, it's not always that way. Later on I worked on two other *Playboy* shoots with two other photographers, and both times it was a disaster. One of them had a terrible way of talking to the models. His comments were infuriating. He would say really stupid, amateurish things, like, 'Just think about your boyfriend.' No one has to tell me what to think about. It was like Photography 101. I finally said to him, 'Let's just do the shoot without the comments.' I want to be treated like a professional. For me, it's best if the photographer is low-key and quietly encouraging.

"In the other *Playboy* shoot, the photographer was really great, and we got along fine, but he just wasn't thinking. I was prepared to pose nude, I'd been introduced to the people on the set, and then another assistant showed up on the set at the last minute. The photographer didn't introduce me, and I didn't know who this assistant was. What made it worse was the photographer sent this assistant around behind me as I was posing. I said, 'Let's do something about this. I don't see why he needs to be behind me when I'm doing this.' That's the kind of situation Nancy would never allow. No thinking, experienced photographer would.

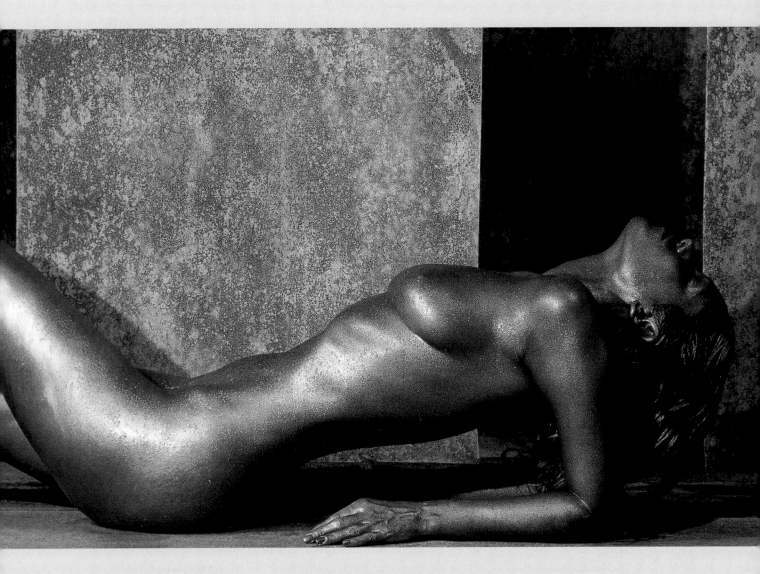

The bronze body makeup was even applied to Lisa's hair for a one-color head-to-toe look.

"My assignments come through my agency, Wilhelmina Models. I've been with them more than three years, doing beauty modeling, lingerie, face shots. I am shorter than most models—only 5 feet 4 inches—so I often model parts of my body; there still is a certain amount of nudity, what they call 'cosmetic nudity.'

"I make the assumption that the photographers I'm going to work with are pros, but that doesn't mean that I'll gel with them or that they'll have an attitude that I can work best with. There is always that awkward moment when you show up on a job and everyone is getting to know each other. At that moment, I'll get a feel for the atmosphere of the shoot, and for me, atmosphere is crucial. A pleasant, professional atmosphere just gets better results. Sometimes you walk into the studio and no one

is introducing anyone or telling you what kind of shot you are going to do, and that always makes it uncomfortable. I like to have information: This is the kind of shot we are doing, this is what we would like you to do, we want you to be happy and comfortable. That gets me on the same page as everyone else, and it gets me thinking about what I can do to help get the best pictures. If I don't get the information until I'm right on the set, I don't have enough time to get into the right frame of mind. So if no one tells me anything, I'll ask. A lot of models don't do that, because they're so intimidated. The moment you get on the set is the moment of greatest insecurity—you don't know if your hair and makeup look nice, you start thinking they're going to hate you. But if everyone communicates, then I know what's expected.

"Models want to contribute. It's really a team effort. I think when the photographer has the attitude that the model has something to contribute, the model will feel more important. A lot of times photographers' attitudes are, 'Oh, just a pretty face, get on the set.' If they want a particular emotion, it's a good idea to have a conversation with the model.

"It seems each photographer has a certain way of working. Nancy can shoot a roll of film in about 30 seconds—she doesn't do a lot of overdirecting. Film is the least important thing to her, so she shoots and shoots. She gives little clues like, 'Happy, happy!' if she wants you to smile. But she generally lets us do what we want. There are other photographers who will direct each frame. The results can be good, but that method tends to stiffen the model.

"Negative comments ruin the attitude, and overdirecting destroys the flow. The photographer may know exactly what he or she wants, but directing my expression and every centimeter of where I stand makes things difficult. If the photographer and the art director work that way, a lot of times I will say to them at the end, 'Can we just take a roll where I just move around? Maybe we'll get something.' Sometimes the pictures will happen that way. It's much easier and a lot more natural when the model is allowed to gracefully move for the camera rather than just being put into place. It's my job to move. But some photographers like to direct each detail, each frame. There's one photographer I work

with a lot who directs that way, and he and I get excellent results. It's a rare thing, but in this case it works. I guess it's because I've worked with him over and over, I know that's how he does it, and I trust him to do it that way. His pictures are very thoughtful and very quiet. They are very personal. It's a different way of working. It's a matter of getting to know the style of the photographer. That particular photographer cannot handle a model who's moving all over the place. And Nancy can't take a model who's just sitting there. She wants someone who has energy.

"In the beginning, there are people who will tell you how to move, and that's good when you're learning. But it's also nice to have someone who will just let you go. It's a matter of finding out on the day of the job just what's expected of you. A good communicator introduces everyone, shows you around. It would be fabulous if they all did that, but some of the best photographers don't do anything—it's part of their whole attitude. But if they don't do it, I usually ask. For me, communication is the most important thing."

Lisa is one of my favorite models. She's capable of a variety of looks and feelings. Her hair is naturally curly, but for a certain look, she'll blow-dry it straight. It's amazing how a different hairstyle and a change of lighting can give a photo a very different feeling. Since Lisa often models parts of her body (hands, feet, etc.), these photos are a great showcase for her.

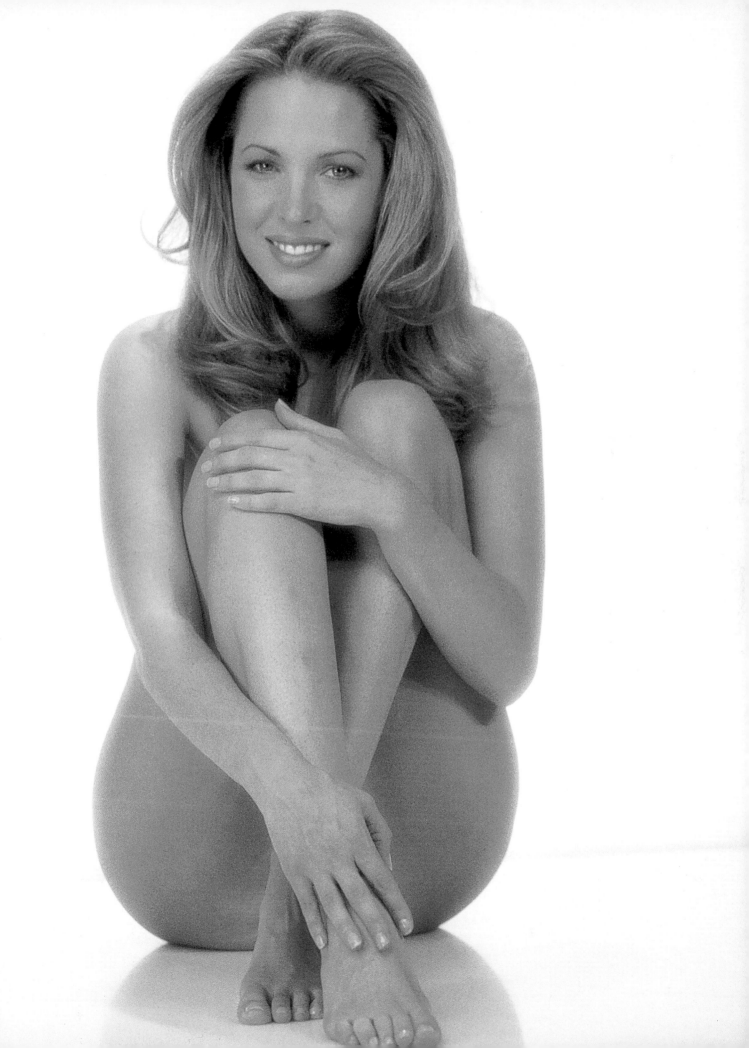

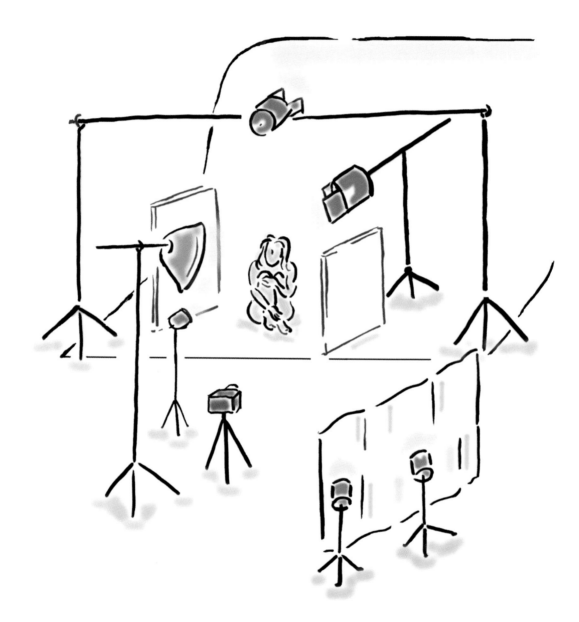

This photo was shot using a combination of strobes and tungsten hotlights for a clean, soft look. The hotlights are gelled with CTB filters to balance them to daylight film. The main light is a large strobe with a reflector. Fill is provided by a small strobe just to the left of the camera and two hotlights diffused with a parachute to the right of the camera. These two lights have 1/2 CTB filters, producing a slightly warm cast. For the hairlight, a hotlight with barndoors is used. Foamcore flats bounce light onto the model and fill the shadows. The model is posing on a white sweep, which is illuminated with a single strobe mounted overhead on a crossbar. Barndoors prevent stray light from hitting the model.

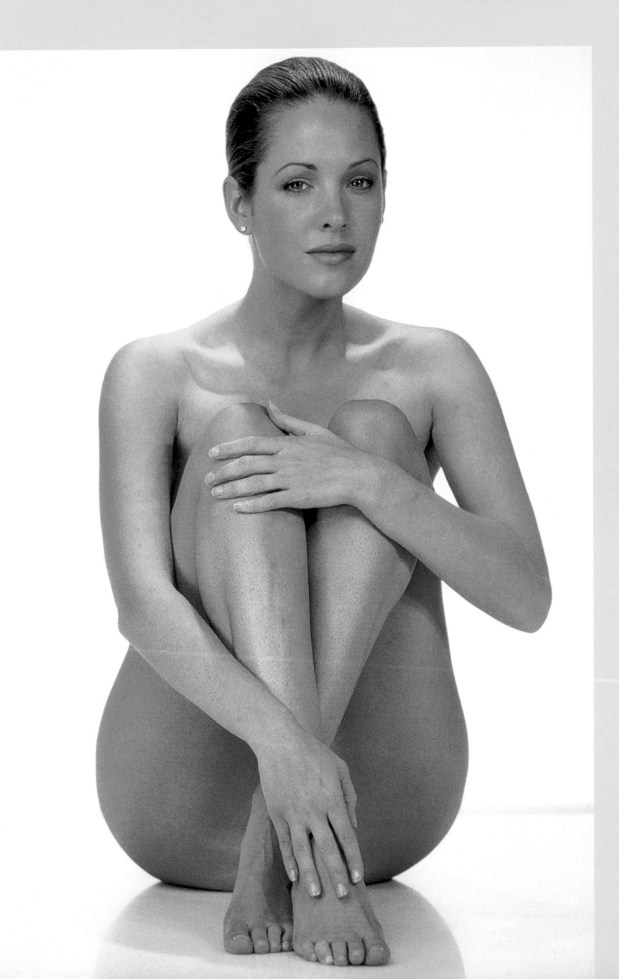

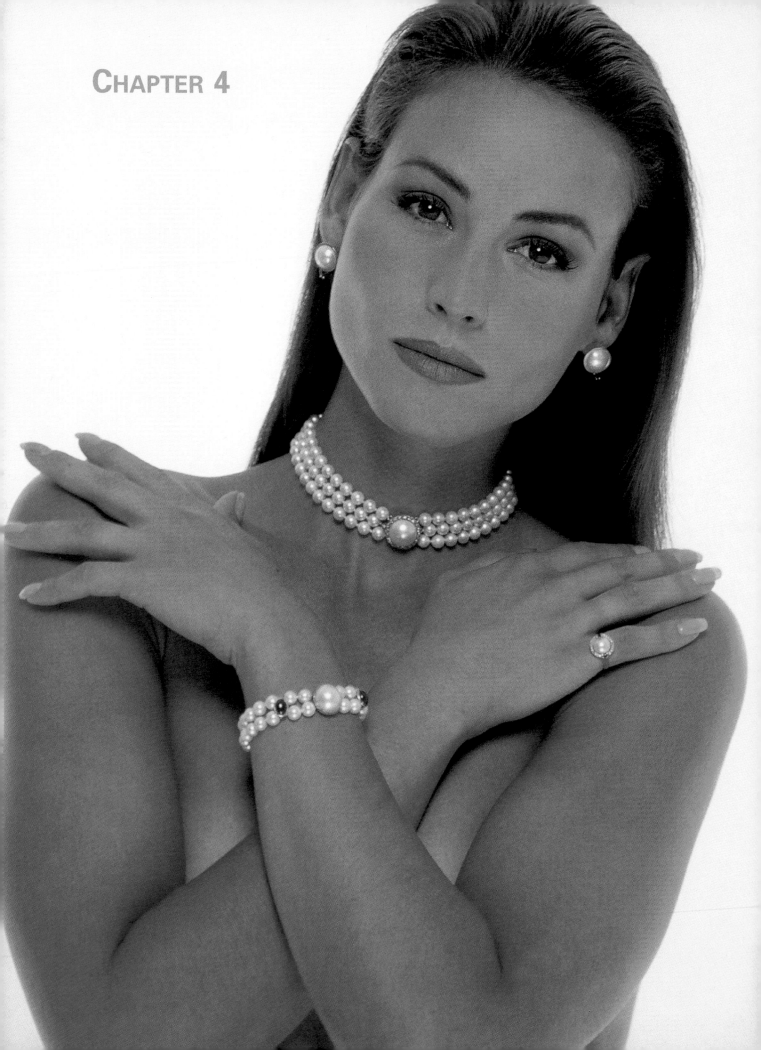

GETTING THE LOOK

While a lot of elements go into the making of any photograph, including models, location, props, clothing, background, and lighting, the look of a nude photograph basically comes down to one thing: attitude. Good, confident models bring attitude to the shoot as do good, confident photographers. Together they create a look that's subtle, genuine, personal, almost private. ■ You'll notice that many of the photographs in this book are profiles. For me, having models look down or tilt their heads a certain way, or having the suggestion of movement in the image, makes for a stronger photo. Photos are actually more sensual that way, because they are suggestive as opposed to being blatant. A model standing nude looking straight at the camera usually won't work. ■ It is important for the model to have a sense of how she *wants* to look in front of the camera. She has to have a sense of what looks good—and what looks better. The best models know how to project their best looks.

But not *all* models know themselves that well. Some see their strong points as weaknesses. You're dealing with self-image, and that's very tricky territory. One of my models just doesn't like herself from the back, which I can't believe because she looks great from the back, far better than most people do. By her standards, though, she just doesn't look good enough, and that's when the photographer has to instill confidence. I'll say, "Oh, c'mon," and I'll show her the Polaroid test shot. "You're perfect." A lot of times the model will come around, but there have been times that even in the Polaroid test shot, the model will see only what she doesn't like. When I run into that, I just laugh and shoot what I want anyway. I'll say, "Get real! We all wish we looked like you do." Almost every human being on the face of the earth is self-conscious about something or other that really isn't a problem at all.

One thing you have to realize is that you'll never get the right look for the photograph—no matter what the location, props, or clothing are—if the model isn't totally comfortable posing nude or partially nude. I don't ever want to take a nude photograph of someone who's not comfortable. The look in the eyes just won't be right; the body language will never be perfect. Models want to please, they want to pose—but if they are uncomfortable for any reason, the photo suffers.

Communicating with Models

Even though you go into the shoot with your plans made, never overlook the creative contribution the model makes to the look. When I talk about a model who's really good, I usually mean that she brings something of herself to the shoot, that at some point she'll begin to use poses and movements that fit into the mood of the shot. And when she does, I go with it, I encourage it. That's when I say those things you hear photographers in movies saying, things like, "That's good, that's great, you've got it, keep it going!" I really do say those things, and when I say them, the model knows I'm telling the truth. I mean them. That's what happens when the energy of a shoot takes over.

And let me tell you: Models like the photographers to talk to them. I talk constantly to my models. On and off the set, I talk to them all the time. The worst thing—and I know this because I was a model for a long time—is when the photographer doesn't say anything. There you are on the set, ready to work, and nothing is coming at you from behind the camera—there's no direction, no enthusiasm, no energy.

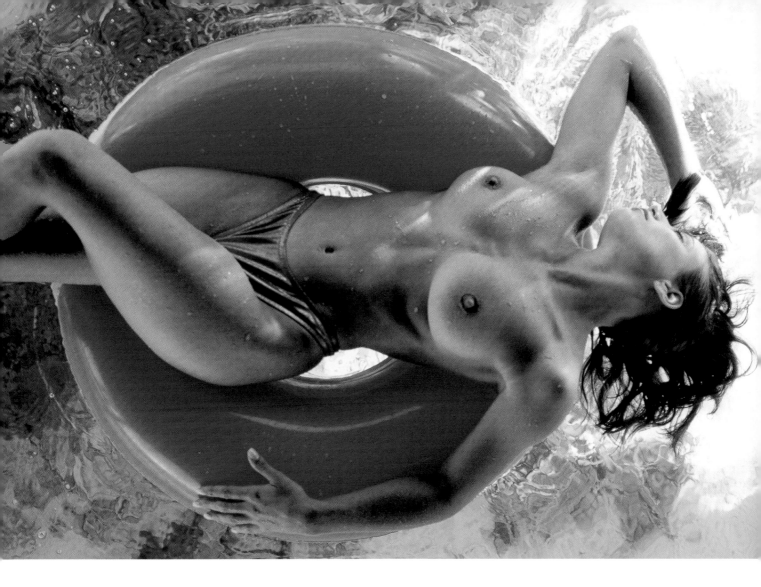

Funny thing is, if I'm not getting the look I want, I'll talk even more. And I'll get out the Polaroid test shot that's really unbelievable—there's usually at least one great one!—and I'll show it to the model. "Here's what we're going for," I'll say.

If there's no great Polaroid test shot to show, and I'm not getting the look for whatever reason, I'll do a couple of rolls and call it a day. That's only if I've been shooting for my own stock or for the model's portfolio. If there's a client involved and I'm shooting for an ad or an editorial illustration, then I have a big problem. Then I'm really out there on my own. What I can do is just call for a break, sit down, and have some coffee with the model. Maybe while I'm sitting there talking—I don't ever want to imply that the model is not giving me something—I might say, "You know, why don't we try this?" If that doesn't work, then I have no choice but to do my best with whatever is working and say, "Thank you very much" when I have as much as I think I'm going to get. Fortunately, that kind of thing happens rarely, because I almost always know the models before they come in for a shoot.

Donna's expression, along with the lighting, helped give the photo a beautiful feeling. Notice the highlights hitting her face and body. The photo was taken on location in Bora Bora from an unusual spot. Under the coffee table in our room was a piece of glass that looked down into the water below. The glass was removable, and I photographed Donna straight down from the opening.

53

I don't like to photograph nudes looking straight into the camera. I prefer profiles and shots where the models turn or tilt their heads. I think that suggests motion and makes for a sensual image.

This scene is lit very soft, with a soft-focus filter used to get an overall look that's warm with peach tones. A large piece of loosely draped satin was used for the background. Three lights, all with warming gels, are illuminating the satin. The model, Suzanne, was seated in a chair positioned about 12 feet from the background. She is lit by a single Mola strobe head on a boom arm. A fill card positioned on the floor in front of her reflects light into the shadows.

I can usually get a head start on "getting the look." Sometimes even before a shoot begins, I'll pull out four or five different tear sheets, and I'll say, "Here's the look we are going for." I never say, "Imitate this" or "Copy this," because that's not what I want. I say, "This is the mood, the feeling we're going for." Now the model has a better idea of what we have to do together to get it. And remember—this is where working with smart models pays off.

I give the model all the clues I possibly can as to what we're going to try to do. Some models are going to pick it up quickly. Some I know so well that I don't have to say much at all about the look. And some, despite everything, are going to be clueless. That rarely happens—again, because I know the models I work with—but when it does, I do the shoot the best way I can and end it quickly.

And sometimes I may have to adjust my goal. For example, a model may be capable of something I hadn't planned or wasn't going for, but what she does is very good, so I'll work with it. She might have a look I hadn't considered.

Or I might get someone in the studio who just doesn't physically look the way I thought she was going to look. There may be a moment of annoyance, but I can't let it rule out the possibility that there's something here I can work with and that there are good pictures to get. I may have to sit down with my tear sheets, come up with an idea from my mental wish list, or change the concept. If, for instance, the model's body is good, I might use angle, lighting, or cropping to play up her strong points and get around the fact that her face isn't as gorgeous as I'd wanted. I've worked with models who had beautiful faces but who just weren't giving me the expressions I wanted. When I'm not getting that animated, bright-light-in-the-eyes look, I end up working with a model who is basically just a prop.

For someone who's shy, I'll make sure she knows it's a private, closed set. I might drape her a bit—add some clothes back, in effect. I won't automatically change the concept of the shot—not yet. What happens is my mind starts working very fast: Gotta save this, gotta save this. I talk to myself a lot, or I might say to my assistant, "We have to do something quick."

But that doesn't happen often. Most of the models I work with like themselves nude—at least, they like certain angles of themselves—and they come in with confidence, ready to go to work. I always try to work with models who are comfortable and want to be nude. There are a lot of them around. It used to be that pickings were slim, but times have changed a lot, and now I'd say that three out of five models have no problem with nude photography.

Deciding on the Look

A model capable of achieving the desired look of the photograph is most important, but before you even start thinking about the model, you have to decide what that look is. I mean, am I going for fresh, clean, all-American, very commercial? Or slightly more suggestive, exotic? That will often dictate the choice of model, because the model's face will be very important to that look. Ads for soap and shampoo, those sorts of things, are almost always straight-on "clean, all-American." And for that look a client will almost always want to look at models' portfolios and do a casting. Here's where I find out if my definition of "clean, all-American" lines up with the client's. I might like to go for a little bit more ethnic, more cutting edge look; the client might interpret the look differently. Of course I have an input, but in the end the photographer goes with whomever the client wants.

When the look has to be "different" or "edgy"—and those are words clients and even photographers use a lot without defining them—I can go with a more exotic-looking model, or I can do a lot with a change in makeup and a shift in my lighting. Or I can change a prop or a background. I can use the same model and get quite a different look to the photo by manipulating any or all of those elements.

Stylists, Makeup Artists, and Hair Artists

While the photographer and the client will dictate the look of the image, and the model will carry that look, there is another contributor: the stylist. You can't underestimate stylists. There are some photographers who feel that the stylist is second only to the photographer in importance; I don't know if I agree with that, but I see the point. In my case, I can be my own stylist, so it is my hair and makeup artist who saves the day for me.

The stylist specializes in finding exactly what you need to make the shot work—a prop, an article of clothing, or a piece of furniture. Since a lot of my photographs are worked out in advance, I don't have to rely on the stylist to find something at the last minute that will make or save the shot—most of my props and clothing are chosen long before the shooting starts. But there are moments when, working with an art director, things change, and all of a sudden you need a white robe instead of a blue one. Often a stylist will work with the photographer from the conception of the idea or from the moment the photographer gets an art director's sketch of the layout. And a really good stylist will not only know where to find the props and clothing but will ask the right questions and make the right suggestions.

I've been working with the same makeup and hair artist for 17 years. We're best friends, and we're so used to working together that we don't have to talk very much about the job—we just go about our business. She is also the stylist on simple jobs and stock shoots.

It's very important that the makeup artist understand the photographer. You have to be able to talk to him or her, and the artist has to understand what you want. It's a key relationship, and it's built on experience and familiarity.

I can understand having separate makeup and hair artists if you have several models booked; while one is doing the hair, the other can be doing the makeup. But if you're working with one or two models, I think that having one hair and makeup person is better, since he or she might be more creative if doing the whole look.

That said, I have to tell you that there are times, especially when I'm going overseas for a location shoot, that I'll work with models who can do their own hair and makeup, even their own wardrobe. It's just a smart decision economically to do it that way if you can, and I often can if I'm going for a fairly simple, direct look to the photographs. If a big fashion shoot demands a lot more, of course I'd take people with me.

If you're just starting out in the business, I'd suggest you get a makeup and hair artist. There's no doubt this will make the pictures better, not to mention relieving you of a big worry.

Where do you find makeup and hair artists if you're a beginner? When I give workshops, I tell the photographers to go to the beauty counter at one of the big department stores and ask the people behind the counter if they do makeup or know of someone who gives makeup classes. A lot of stores have experts come in for "makeover" days; those are the people you want to find. Several photographers who've taken my workshops have found their makeup artists exactly that way, and it's made a big difference in their photos.

Often a nude or beauty shot will require body makeup, perhaps to cover a scar or smooth an imperfection, and there is special makeup for those purposes. A good makeup artist will know how to apply it, but it's up to the photographer to make sure the artist knows ahead of time what will be required, that you're going to be photographing nudes.

Some feel that a woman will be more comfortable with another woman applying the makeup, especially body makeup, and it certainly is a consideration. But frankly, I don't think it matters much these days. In all the years I shot for *Playboy*, we had a male makeup artist who did faces, bodies, everything.

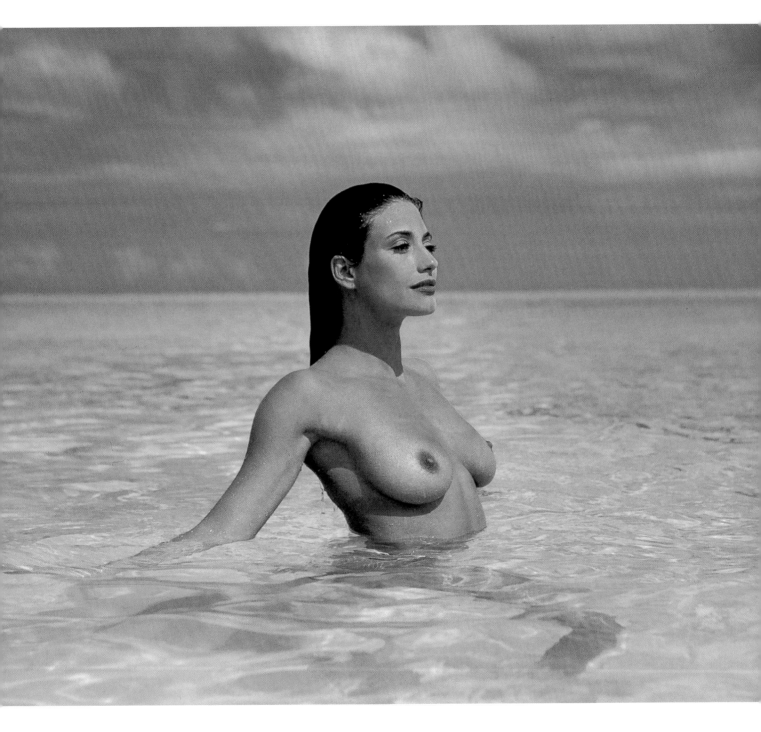

Water is great to work with...and in. Here it covers half of Donna's body, and while she might have been a bit uncomfortable walking down the beach nude, walking in the water was easy. Her regal bearing and great expression make for a strong, memorable image.

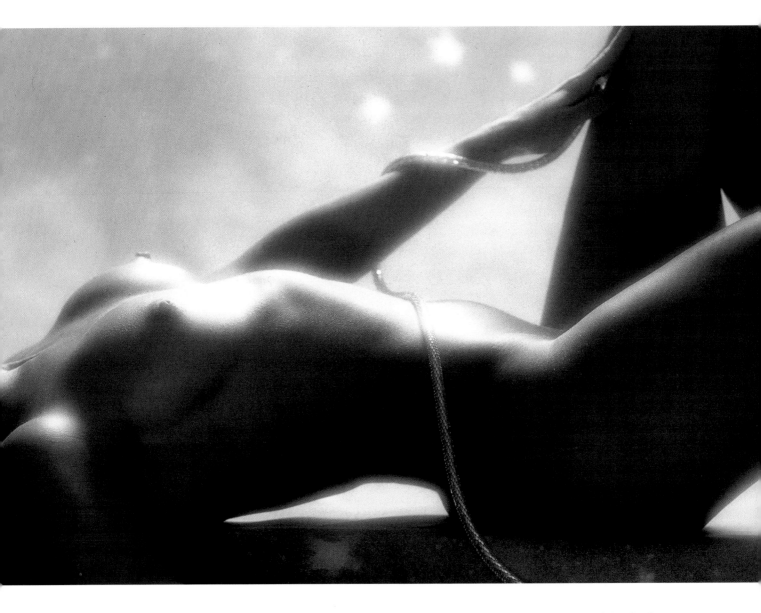

I wanted a very dramatic look to the lighting here. A bank light that's usually used for still-life shots, not for people, is positioned directly over the model. When I started shooting, it felt like something was missing. So I went to my prop closet and found the silver belt.

Sometimes you're going to be looking for something special in makeup, as I was when I did a photograph of a gold-painted model. For something like that, it's vital that you tell the model all about the shot ahead of time. In this case, she was fine with it—she poses nude all the time, so that didn't bother her and neither did the paint. She was very comfortable with it. In fact, she was the one who suggested we put it in her hair. At first we were going to just paint her body and have her hair styled. But she said, "This would look a lot better with the gold in my hair, too." We got the paint at a makeup center; it's nonallergic, but we tested it on the model just to be sure. And it all washed off in the shower without any problem.

This was an interesting shot from the point of view of the concept. A photographer who was renting my studio for some work gave me the background as a gift. He said, "This could be good for the kind of photographs you do." Then when I began thinking about photos for this book, ones having to do with the look of nude and beauty photography and props, I remembered the background and thought it would be great to work with, to use as the starting point for a photograph. It's a painted parchment, and its gold and marble look suggested making up a model to look the same way. We did it all in one day. The paint went on easily enough, but every time she moved or changed position, we had to touch it up.

It's important to remember, though, that even with the photographer's arsenal of effects that will influence the look of a photograph—lighting, filters, film, props, and styling choices—the important thing is for the photographer to know what he or she wants, to have the concept, the look, as a starting point.

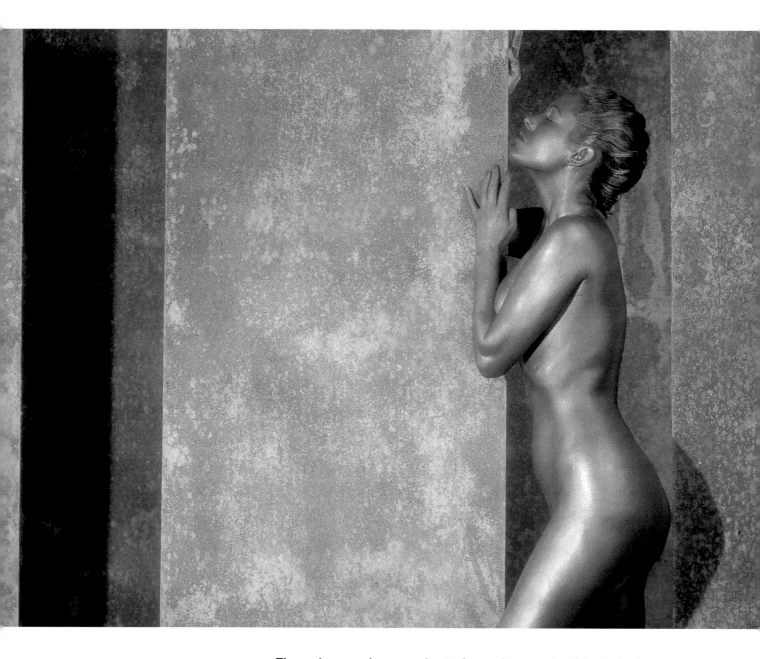

These photographs came about after a photographer friend of mine rented my studio and left behind this painted background. We decided it would be a great idea to use body paint on the model in the same tones and textures as that background. We got the paint at a makeup center. We even did her hair in gold.

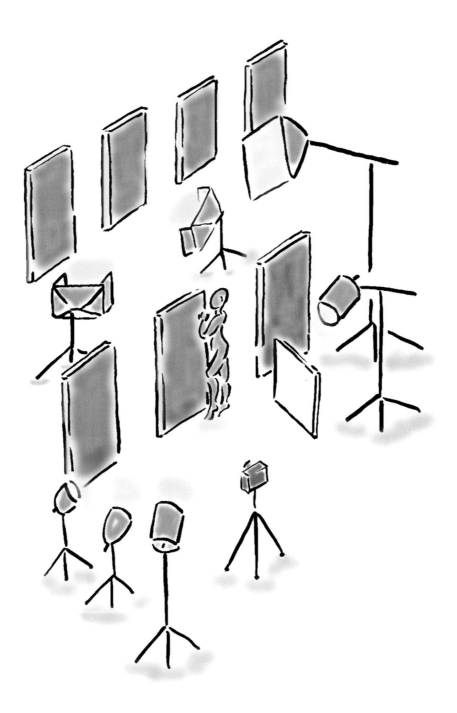

The sections of background, panels painted with a metallic bronze distressed look, are set up in two layers. Two 2000 w/s strobes and a 4000 w/s strobe—all with pan heads—illuminate the back layer. Lisa is lit with two 2000 w/s Fresnel strobes and a day-balanced HMI hotlight. Positioned behind the model are a fill card and a small hotlight directed at the floor.

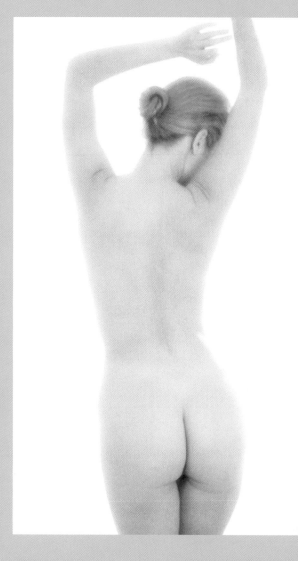

We were working on a feeling here. I basically let the model pose as she wanted to, in the hallway of the studio. I used filters, threw the image into soft focus, and deliberately overexposed some of the frames. Nothing is really, really sharp. This was probably the only time in the book that I wasn't shooting sharp, on purpose.

Testing Ideas

Almost all of what I do is for a specific purpose—either to fulfill stock assignments, for a client's advertising, for a model's portfolio, or for images for this book! But there are times when I like to shoot pretty much for the sake of trying something new or testing out an idea. I think it's a good idea for all photographers to find the time to do this.

Because almost everything I do is sharp and clear, I wanted to play with the idea of deliberately using soft focus, heavy filtering, and even overexposure to see what kind of look I could get in both color and black and white.

I wanted a very low-key, low-pressure atmosphere and a model who would feel free to pose and move pretty much on her own as I shot. Lisa was perfect for that, and we spent a few hours working on this look.

I deliberately did away with any formal background or set. We shot in the hallway of the studio so Lisa wouldn't feel restricted—she was free to move around as she wished. I bounced the light around, giving the whole thing a very diffuse look—it's like she was in a box of light. And of course, she had the walls to lean against and to use in her poses.

She had fun with it and was very playful in the poses—sometimes exaggerated, always sensual. And part of the experiment was for me to shoot as she moved, to give a slight blur to some of the images. There was a lot of freedom in this—I was free to shoot in ways I don't normally do, and I liked getting away from the razor-sharp look of most of my photos. And Lisa was free to make it up as she went along, to pose and improvise without worrying about hitting an exact spot or staying in front of a backdrop.

Sure, the meter was running—I paid her for a half-day's session—but I think it's good to shoot just to experiment, when there's no purpose other than trying new things to see if they work; if I like them, I can use them in the future.

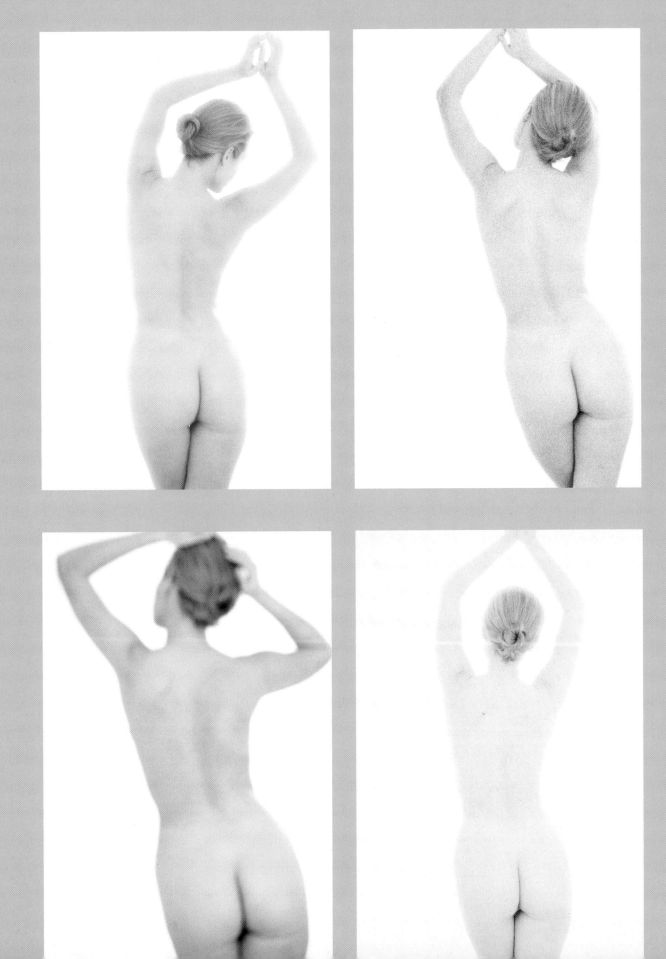

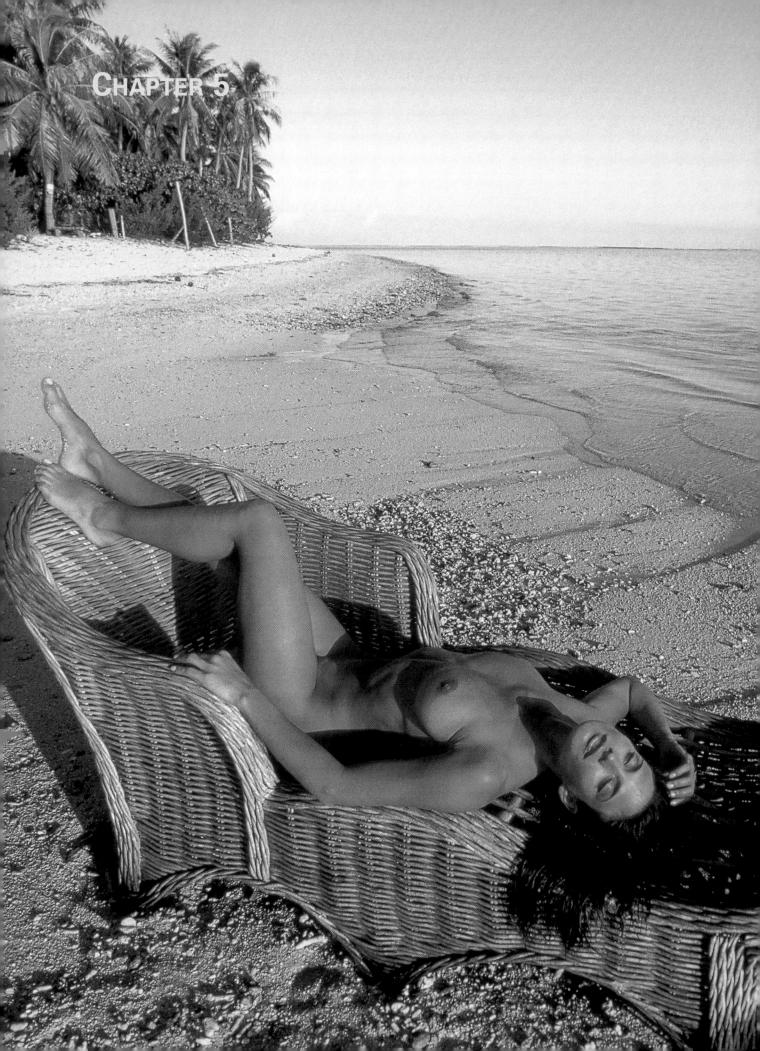

CHAPTER 5

THE NUDE ON LOCATION

I think one of the best things a photographer can do to put freshness and vitality into nude and beauty photography is to get out of the studio. I'm not necessarily recommending that you do all of your nude and beauty work outdoors, but I've found that it's a dramatic change of pace that suggests new ideas and opens up all kinds of opportunities. ■ Lately I've found that most of my shooting, perhaps as much as 60 to 70 percent, has been done on location. That's simply because as the stock business has grown, buyers prefer real locations. The more real it looks—whether it's a kitchen, a home, or a beach—the better. The illustrated look, for which photographers build rooms and sets in the studio, doesn't work for stock. Stock photographers need real rooms, real light, and real sand. ■ I prefer doing nudes on location. It's more fun, and I get more done, too, because with just a slight change in the natural light, I get a whole different look to the photograph. In the studio, I make what I get; on location, I see it happen and then I get it.

Whenever you see my assistant with a clipboard, he's taking notes on the shots—what we've got and what we still need.

These days booking trips to locations near and far isn't the chore it used to be. The computer has made everything simpler. I can contact a travel agent and have everything taken care of as a package, or I can sit down at the computer and pretty much make all of my own arrangements. It's even possible to scout locations over the Internet. For a recent Bahamas trip, I was able to research hotels and find the kind of beach I wanted—an isolated one out of sight of hotels and private homes. At a certain point you have to call and ask a lot of questions, but all the choices are displayed for you on the screen.

The year before I began working on this book, I'd done some photography in Bora Bora. It wasn't exactly a beauty or nude assignment, but it was close: a series of health- and fitness-related images for which I photographed models swimming, jogging, and doing all of the good, healthy things an athletic person might do.

It was such a wonderful location that I knew right away I would someday come back to do more work. So when this book project came up, I planned a week on Bora Bora to produce nude and beauty shots. And because the location was so distant and exotic, I was determined to make photographs that would serve several purposes. You don't waste an opportunity like that! So while most of the nudes were taken for this book, I also did variations of every

Here we are on location in Bora Bora. That's me in the tree—I'd gone up to cut a tree limb off so the palm tree would look better in the background. My model took this photo as a joke.

nude shot using a towel or with the models wearing swimsuits. That way, I'd have photos to sell in other markets and to show in my portfolio—and the models would have a variety of great images for their composites.

If the most important thing to me about a model I'm going to photograph in the studio is great skin, then it's doubly so for a model I'm going to work with outdoors. The prerequisite for the Bora Bora shoot was a model who could stand the sun, preferably with a real tan in addition to a perfect body—Donna has it all!

Just as important, when you go on location to do nude and beauty photography, you have to be sure you're going to the right location for nude and beauty photography. Photographers have to do their homework. Obviously, the season and the weather have to be right—or as right as you can determine—but the area also has to promise privacy. Nudity is perfectly acceptable on the beaches of Bora Bora. If I'd decided to stay closer to home in North America to do the work, I would have looked for a private beach where I could photograph without being disturbed. I know there are several places

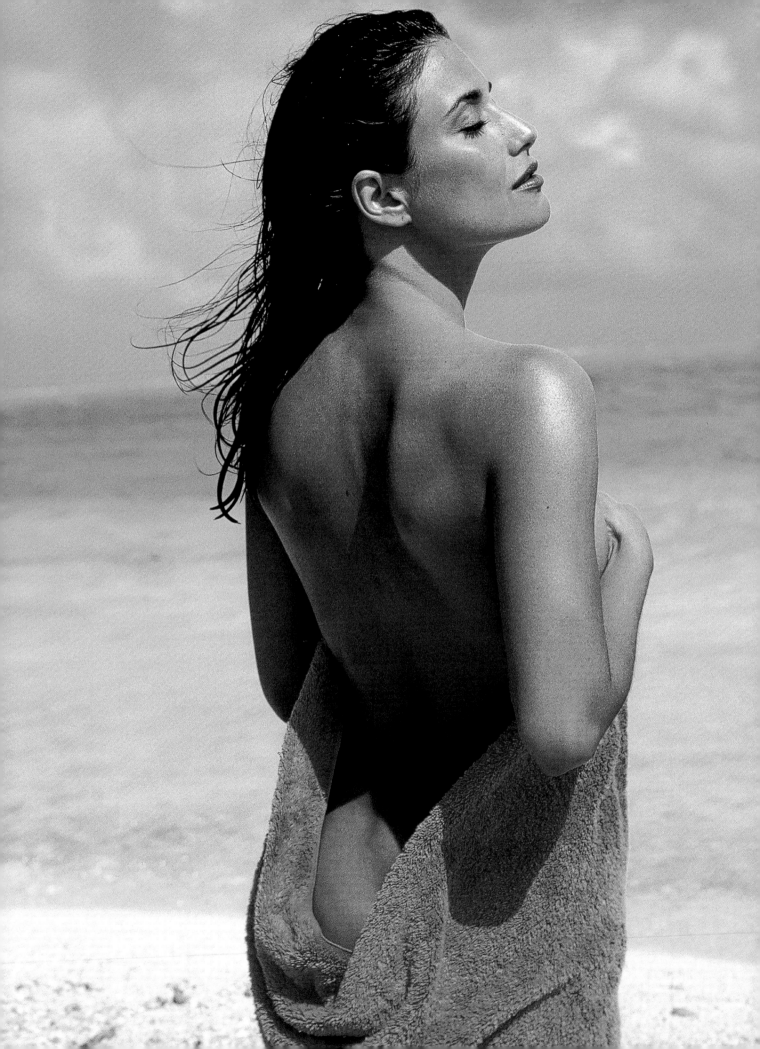

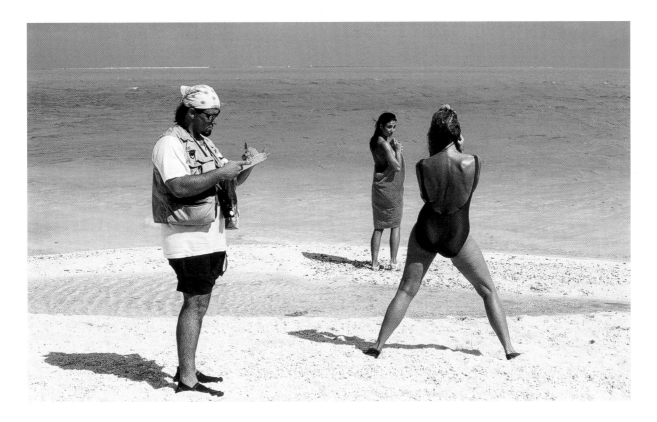

in Mexico where photographers regularly shoot nude photographs.

That's not to say that the photographs have to be taken at a beach. I've often worked in gardens and on lawns. It's just that I love the water—it fits with my romantic nature. There's something about the water that's right for me and the way I like to work.

A beach will generally give me the natural shapes and forms that work so well with nude and beauty photography. That includes rocks, which provide a great contrast in texture when my model is lying near or on one. Texture is one of the most important elements in this type of photography. In one instance I found a rattan chair on the beach and used it simply for the contrast between its texture and the model's skin.

Of course, the beach also means tides, which means more homework. You want to know when you're going to have a high tide so you can work with the water right near or on the model, and you want to know when a low tide is going to provide a great expanse of sand to work into the picture.

Bora Bora gave me everything I wanted for foreground and background elements: water that was never choppy or rough, a great horizon line, and a coral reef. And when I turned away from the water, I had a whole new set of things to play with and work into my images, including the rooftops of nearby huts. When I

Donna was holding the pink towel around her, waiting for the next shot. I liked the lighting and took the photo. The towel adds color, and I like that with the towel, the photo only suggests nudity.

I take 16mm film as well as still photos for stock sales. When I go to the expense and trouble of a location shoot, I try to get as much business out of it as possible. In the center photo, Faye Looney, a photographer friend of mine, is acting as stylist. The resulting photo of Donna and Michael is one of intimacy and romance.

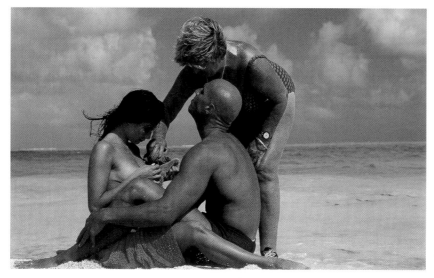

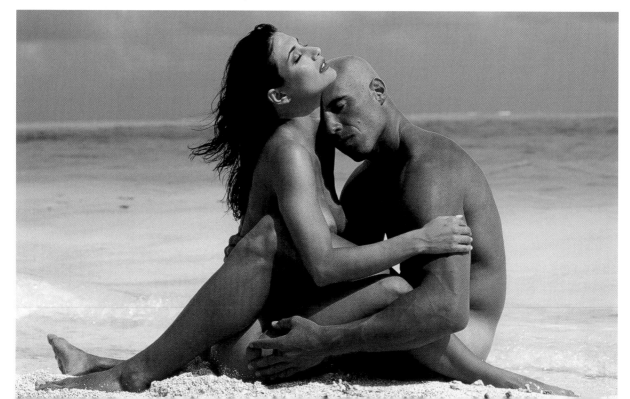

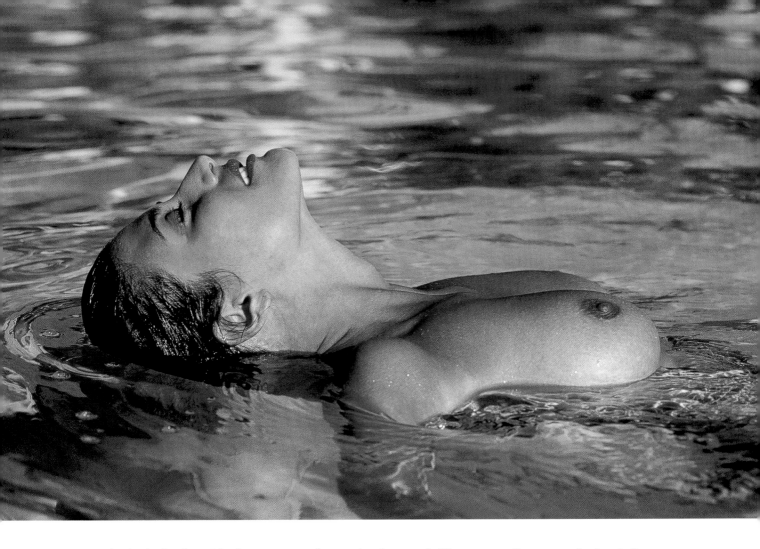

turned a little further, I had mountains for my background. The point is, if I am going to invest a lot of time, energy, and money, I want to go to a place that will give me a lot of different views.

Anticipate the Limitations

But working on location imposes its own limits. Away from the studio, I don't have the benefit of perfect and total light control, and as much as it's possible, I have to bring that control with me. You've probably heard that the best light for location photography comes in the early morning and the late afternoon. Well, I agree with half of that. I've never found morning light to be particularly wonderful. It comes up really fast, it's good for only a few minutes, and it starts getting bad very quickly the closer you get to noontime. I like working in the afternoon, from about 3:30 to sunset. I maintain there's not a soul in the world who looks bad in that soft, diffuse, flattering light—especially in the phenomenal light of the last hour.

Unfortunately, I can't plan my shooting around late afternoon light only. So I'll shoot in the morning until the light goes bad—meaning it becomes harsh, direct, and unforgiving—and then I'll begin working with umbrellas and reflectors in order to control the light as best I can.

73

Sometimes you just have to outthink the light; I've found I can get away with noontime light if I'm shooting down from a high angle with the model right below me. With the sun directly above, I can get a nice look to the photograph.

Being out of the studio not only deprives me of lighting control, it also means I can't go to the prop closet or dash down the street to buy what I might need to help a shot. In many cases, you can't count on being able to buy what you need, especially if you're struck by a sudden inspiration and need an exotic prop or effect to make the idea work. (Sometimes on location you can't count on being able to buy *anything*.) So while a lot of things happen spontaneously—and sometimes the best things happen that way—working with models on location means thinking way ahead about what you want to do, what you might want to do, and what you'll need to do it.

Bora Bora is a very noncommercial island. I'd been there before so I knew I couldn't count on buying much in the way of props or wardrobe. I did find that rattan chair on the beach—one of those totally spontaneous things—and it turned out to be a great prop, but for the Bora Bora shoot I made sure we brought a lot of stuff with us: colorful blow-up inner tubes, snorkel masks, flippers, netting, fabric wraps, and of course, many swimsuits and dresses. For a location shoot I always take more than I use, and I never go without everything I think I might need. If I pick up some colorful or interesting local items to use as props or backdrops, that's a bonus, but I never count on it.

The fact that it's a nude or beauty shoot doesn't change any of the rules of location work. I had to be sure we were taking all the equipment we would need, but because I knew we'd be working on the beach in the sun, I brought along a small, two-person tent to keep all the gear safe and out of the sun while we worked. I bring all the film we're going to need, and I keep all the exposed film with me at all times, but never in the same bag.

Equipment on Location

As much as possible, I travel light: only two camera bodies—a Nikon N90 and a Nikon F4, two 80-200mm zoom lenses, a 35-70mm zoom lens, a 20mm wide-angle lens, and a 200mm micro lens. I also carry a Nikonos underwater camera—I don't do underwater shooting, but I do get into the water! Then there are filters for all of my lenses—polarizing, 81A, 81B, and soft-focus. And the tripods for the cameras.

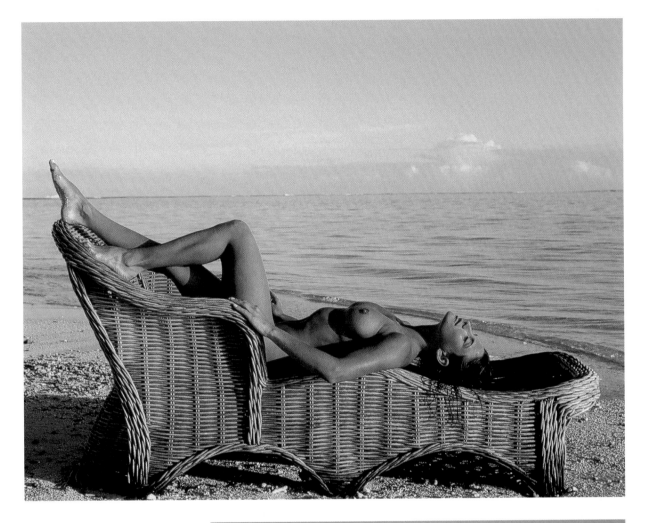

When we got to the island, we found a wicker chair on the porch of a house. We asked the owners if we could use it, and since it was old and going bad, they even let us put it in the water. We got a lot of mileage out of that wonderful wicker chair.

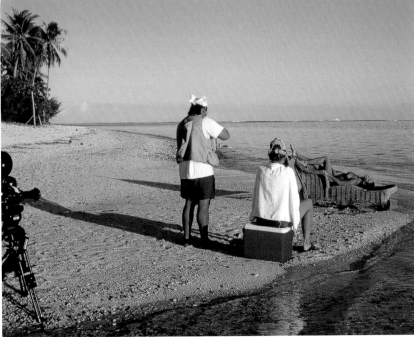

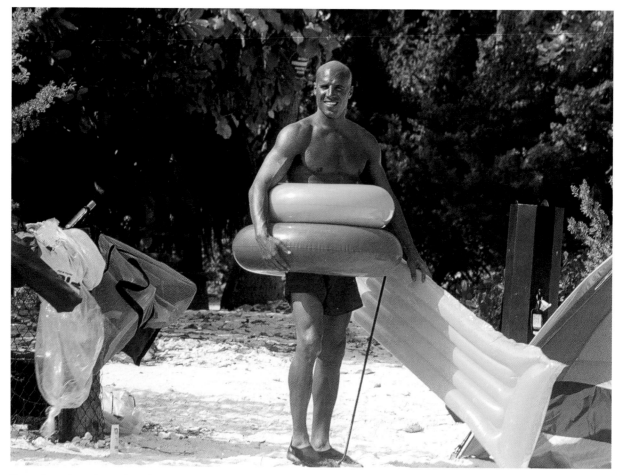

For a location shoot, I make sure we bring a lot of stuff with us, like colorful blow-up inner tubes, snorkel masks, and flippers. I always take more than I use. If I pick up some colorful or interesting local items to use as props or backdrops, that's a bonus, but I never count on it.

To control the light, we carry Scrim Jims—lightweight aluminum frames in a number of sizes and shapes that can quickly be put together and from which I can hang reflection or diffusion material. We take a lot of space blankets, too; those silvered, insulating blankets are great for a lot of things. We can lay equipment on them (rather than put anything down on the sand!) or use them to cover equipment; they'll even become reflectors in a pinch. Best of all, they're lightweight and take up very little space.

And because I know I can't really count on the weather, I always carry black-and-white film. When it's overcast, the color film stays packed, and I use the black-and-white. I'll never waste an opportunity to shoot—in fact, I've learned that bad weather can be very good for stock photography. No matter that I came to photograph nudes in the sun, I can always come up with something if the weather goes against me. Like people's reaction to bad weather. One time I photographed people on a dock in their flippers in the pouring rain; they looked angry and disappointed, and I sold that shot for stock.

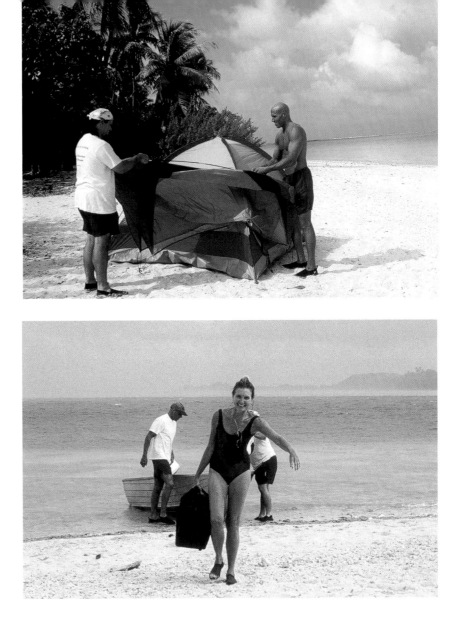

To keep everything as cool and as safe as possible, any equipment or props we're not working with at the moment are kept in the tent, which is also where my assistant, Jonathan, changes all the film. That's where I'm headed with this case. The sky started getting dark, and we knew it was going to rain in a few minutes.

I guess that illustrates the key to location photography for me: Use what's happening. Take advantage of the spontaneity and energy. That's why I don't take Polaroid test shots on location. I look through the viewfinder, and I take the picture. If I stopped to take a Polaroid test shot every minute, I'd lose that energy. That's why I'm addicted to zoom lenses now. I never used to use them, but now I almost always have one on the camera, because as things start happening, I just keep shooting. I'll start a shot really, really tight, then all of a sudden I'll pan back, and there it is! This is really nice, too! I can make a case that zoom lenses were made for stock shooting: You can be shooting the overall scene then come in quickly on the model's expression without having to interrupt the flow by stopping to change lenses. I let whatever is happening happen. The unplanned can be the best shot. When the model's hair is blowing in the wind or getting wet, I let it. In fact, that's why I chose one particular model—she has a very strong face and looks really good with her wet hair slicked back. I told her, "Don't even bring a blow-dryer!"

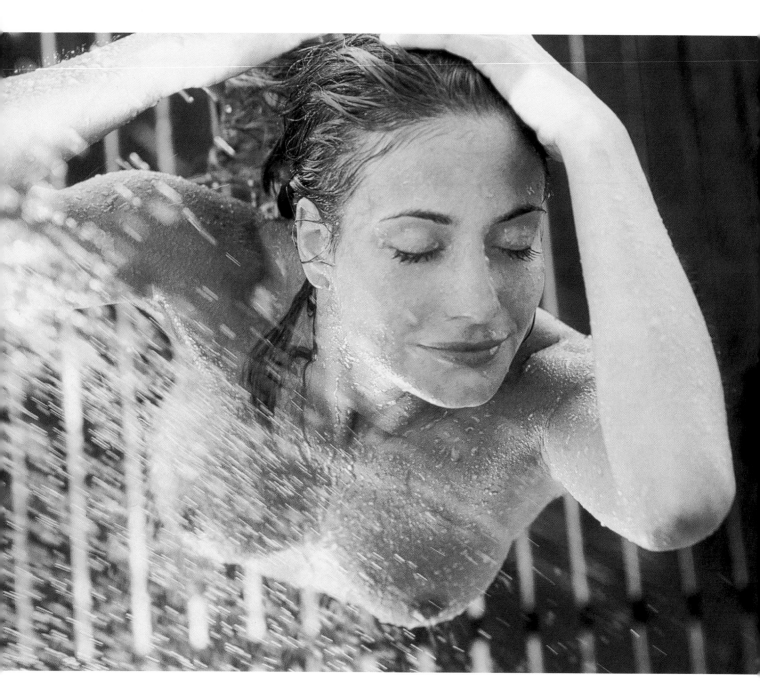

On location you take advantage of everything you're given. We had an outdoor shower by our room, and I took this photo of Donna from a deck above the shower. It's a great stock shot, because it can be used for any number of products or locations.

The Bottom Line

Ultimately, location work for nude and beauty photography isn't much different from other location work—it comes down to logistics and planning. And of course, travel can be expensive. When I'm shooting for stock, I'm paying for everything. It's an investment that may not pay off for years, so I try to do everything as economically as possible. I don't stay in $600-a-night resorts.

One of the things I can do about expenses is work out a deal with my models in which I pay them for the trip and also give them a lot

of photographs for their portfolios. Of course, for a location shoot I pay them a lot less than I would for days in the studio. For example, in the studio I'll pay $700 a day, but if I take a model on location, I might offer $1500 for a whole week, plus all expenses. I couldn't afford $700 a day for stock photos—no photographer can. The thing is, models usually love to go on location, and I've never had trouble finding models at rates that make sense for me. I once did a location shoot in France and brought a dozen models at very reasonable rates. They were so anxious to go that I think I might have convinced them to do it for expenses only! That trip was, as you might imagine, a big money deal. I shot stills and film, all for stock, and it was a huge investment that took over a year to pay off.

The way to make location photography work is to get a lot of mileage from the photographs. If I just did one thing with the pictures, I might not get my investment money back. So I try to cover a lot of bases—it's not just shooting nudes, it's beauty, health, faces, stock situations. True, I might sell one shot for astronomical money from a trip, but I don't count on that. I count on the long-term, little-by-little sales. That's the realistic approach.

If their schedule permits, most models will jump at the chance to go on location.

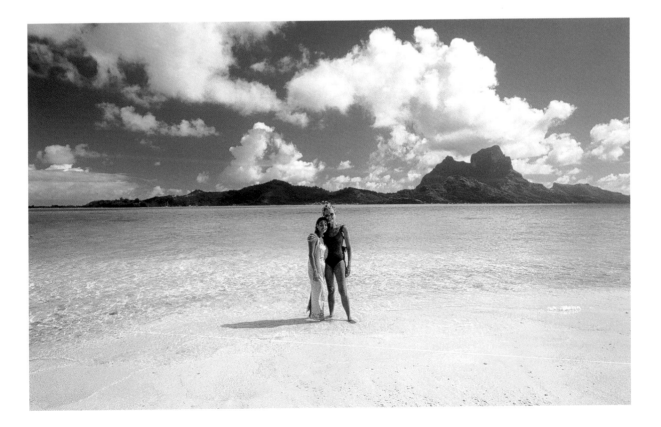

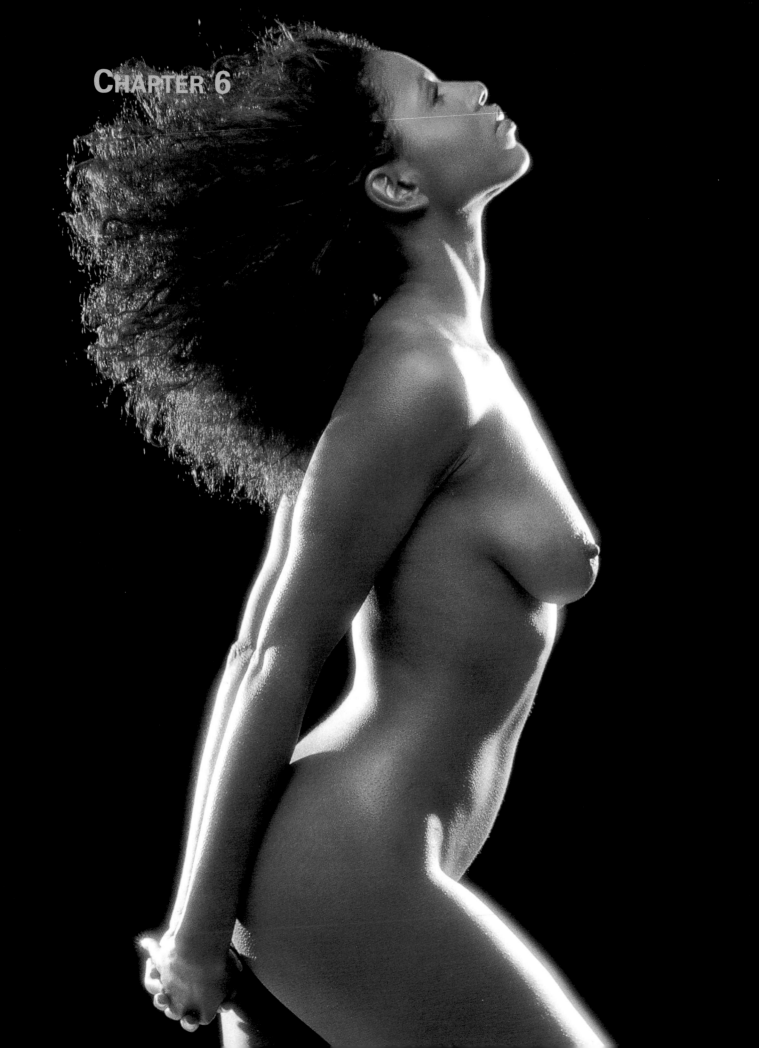

LIGHTING THE NUDE

Here's how important lighting is: I've heard that Hollywood actors and actresses have shown up for television talk show interviews with their own lighting technicians. These people have to look good, and they know how important lighting is when it comes to concealing flaws and making them look their absolute best. It's just as important in still photography. ■ In one sense there isn't that much difference between lighting for a nude and lighting for someone wearing clothes. The lighting in both cases depends not so much on the subject, but rather on what I'm trying to do with that subject and on the kind of picture I'm trying to take. I might light one nude differently than another, just as I would light one fashion or beauty shot differently than another. The feeling and the mood make the difference, not the fact that there are or aren't clothes.

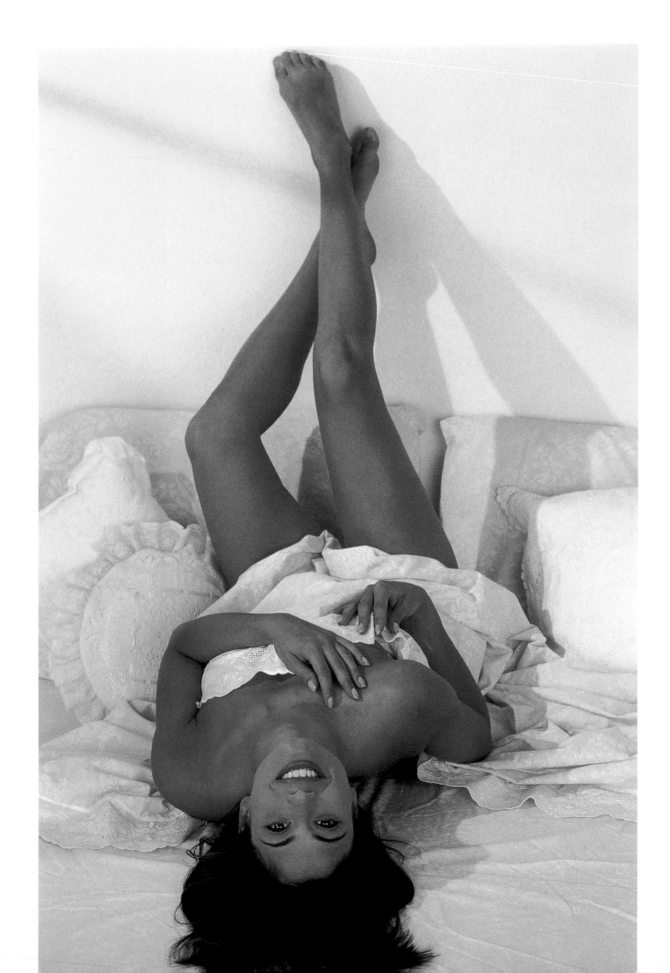

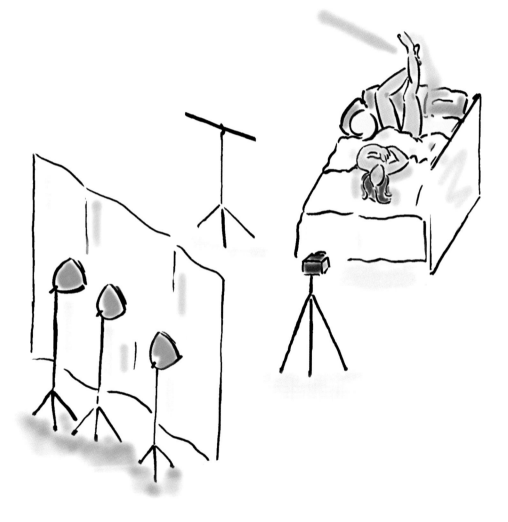

The mood here is fun and playful, and the light is also open and friendly, coming from above as if through a window or skylight. I wanted it to look like morning light. The setup for this shot is simple yet effective. The light from two strobes is diffused with a parachute, and a large fill card reflects light back at Donna. For added interest, an extension arm on a stand casts a shadow near the model's ankle.

But there is one way in which the lighting does differ when I'm photographing nudes. I want the model's skin to be very soft and pretty. With clothing, I want more detail, more texture, but I don't want to see texture in the skin; the last thing I want is to show every pore. So my lighting for nudes is almost always softer, more diffuse. I don't want to show every detail. The atmospheric quality of the soft light adds a feeling of romance and mystery; you don't want a nude photo to look like it's out of a medical journal.

Rim Lighting

One of the most dramatic lighting effects you can use for nude and beauty photography—it's a technique used a lot in Hollywood—is to rim your subject, meaning you have most of the light, the main source, coming from behind the model. No light is directly hitting her. The light is positioned so the model blocks most of it, and what you have is a bright outline or halo effect around your subject. It's a common but effective technique.

For example, what makes the photograph on page 80 so dramatic is the combination of background and lighting. I set up the back-light to rim her body and hair, and that effect works only against a dark background. The lights behind her are very strong, but they're a good distance away from her so they don't blow out the exposure. There's no lighting from the front—just two reflectors bouncing the rear light back at her.

When I do that kind of lighting, I set up 4 x 8 foamcore reflector flats, which are formed into right angles, in front of the model to control the light that's reflected back onto her. In effect, the reflected rim light becomes the front light, and by moving the flats closer or farther away from the model, I can control the amount of light that reflects back onto her. If I move the flat closer, I'm going to get more detail in the photo; if I move it back, I'll get more of a silhouette. It's the same with my backlights—the farther back they are, the softer the rim of light will be. If I move them in tight, I'm getting a pretty strong light. I have to watch for flare on my lens in this situation, but it's a technique I use a lot.

Don't Overdo It

The key to lighting is not to overdo anything. You don't want viewers to look at a shot and notice the lighting; you don't want the lighting to announce itself. If it's overpowering, it's obviously a gimmick. Some people like gimmicks—most of the movies made these days are gimmicks—but I've never been much for them.

My first question is, am I lighting for black-and-white film or for color? With black and white, I'm lighting for contrast; black and white is inherently more contrasty and, I think, more dramatic. I won't use the same lighting for black and white that I will for color. Generally, for black and white I want a crisper light and more definition, more shadows, and a sharp demarcation between tones; I want to separate my subject from the background. So I'll set my lights for more sidelighting rather than direct, straight-on lighting.

But as the Hollywood actors and actresses know, lighting is not only about bringing out mood and detail. It's also about hiding imperfections, and this is where you have to arrange your lighting to suit your model. Hard, contrasty lighting isn't going to work unless your model is really good-looking.

To control the light, I use Scrim Jims—lightweight aluminum frames that come in a number of sizes and shapes and can be put together quickly. Photograph courtesy of The F. J. Westcott Company.

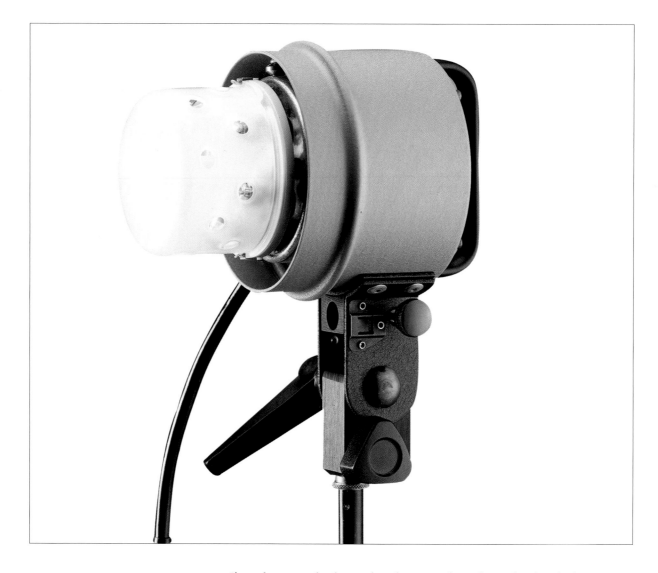

I keep the lighting basic. The Dyna-Lites on booms in my studio are easy to roll into position and easy to roll out of the way. Your choice of lighting is a matter of personal preference and budget. Photograph courtesy of Dyna-Lite, Inc.

I've photographed people who were less than absolutely beautiful—say a friend or a relative who wants a portrait for a gift—and when I want to make them look absolutely beautiful, I light them very, very softly, and I always use a filter. Bounce light—light that's shot through an umbrella rather than head-on—is the softest light of all. I've also shot through parachute material—sometimes I'll double or triple it, and that's *very* soft.

On location, you'll get the softest light late in the afternoon. Or use reflectors, Scrim Jims, or anything that overhangs the area—a pretty porch, a thatched roof, anything the location offers.

I don't consider myself to be a lighting technician, but I do have to be totally familiar with my lighting setup. That's why I like to keep it simple and stay with what works for me. I've been working with my Dyna-Lites for so long that I know exactly what they're

going to do for a scene. I know which covers are a bit warmer than others, I know when I need to use parachute material to soften the light, and I know when I need to bounce the light for fill.

The way a photographer lights creates style. I do a lot of things with lighting, but my style tends to be more soft and glamorous than anything else. I like contrasty light, but I use it sparingly.

For the Beginning Photographer

I think the best thing a beginning photographer can do is start with just the basics. Get a power pack and a couple of heads and learn everything they can do. Learn to use them with umbrellas, with reflectors, with bounce light. Once you've learned how to use that basic setup for everything it'll do, then add to it. You might bring in a third light to fill shadows or to use as a hair light.

I think you'll find that you won't really have to add that much. It shouldn't ever get complicated. The worst thing photographers do when they start is to overlight everything; when they could use two lights, they have five. I've seen photographers in studios light a background with six heads and then do a head shot of their subject—an incredible overkill. They could do it with two lights, but I guess they feel that since all that equipment is there, well, they'd better plug it all in. Remember my advice: Start with a pack and two heads, and explore what you can do with bounce, front light, and backlight.

That said, I have to tell you that there are situations that call for lots of lights—and lots of control of those lights. When I shot for *Playboy*, we did every shot with a minimum of five lights. We made a lot of use of grids-lights with a grid-like mesh on them that helps focus the light—which I never use today for my work. We had a system for the lights: one on the model's chest, one on her bottom, one on the hair, one on her face, and one in reserve for anywhere else we found we needed it. We'd use snoots, too, which pinpoint the light—it's a very specific light pointed at a specific place. It meant a lot of Polaroid test shots and a lot of adjusting, but it was the way to get that *Playboy* look to the photographs. It was a formula, and it worked, but it sure wasn't simple.

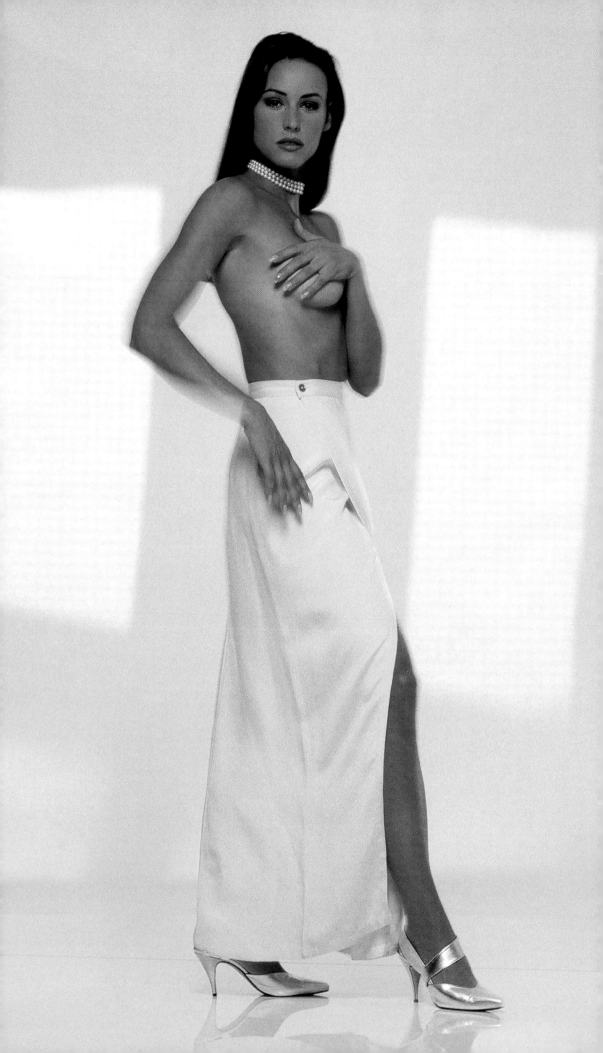

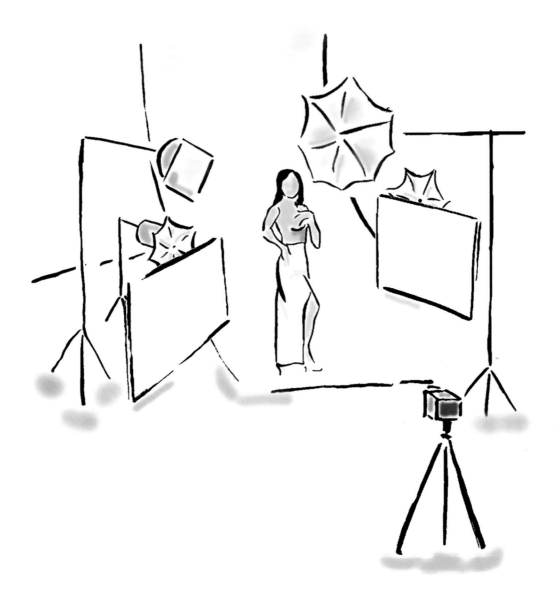

The background—white seamless paper—is illuminated with two strobe heads equipped with umbrellas. Flats are set up to prevent the light from hitting the model. Laina is illuminated with a single strobe on boom arm. At one point, sunlight came through the studio windows behind the background and created the two squares of light. I used a slow shutter to expose for the squares and also got a little of the model's movement, which I like.

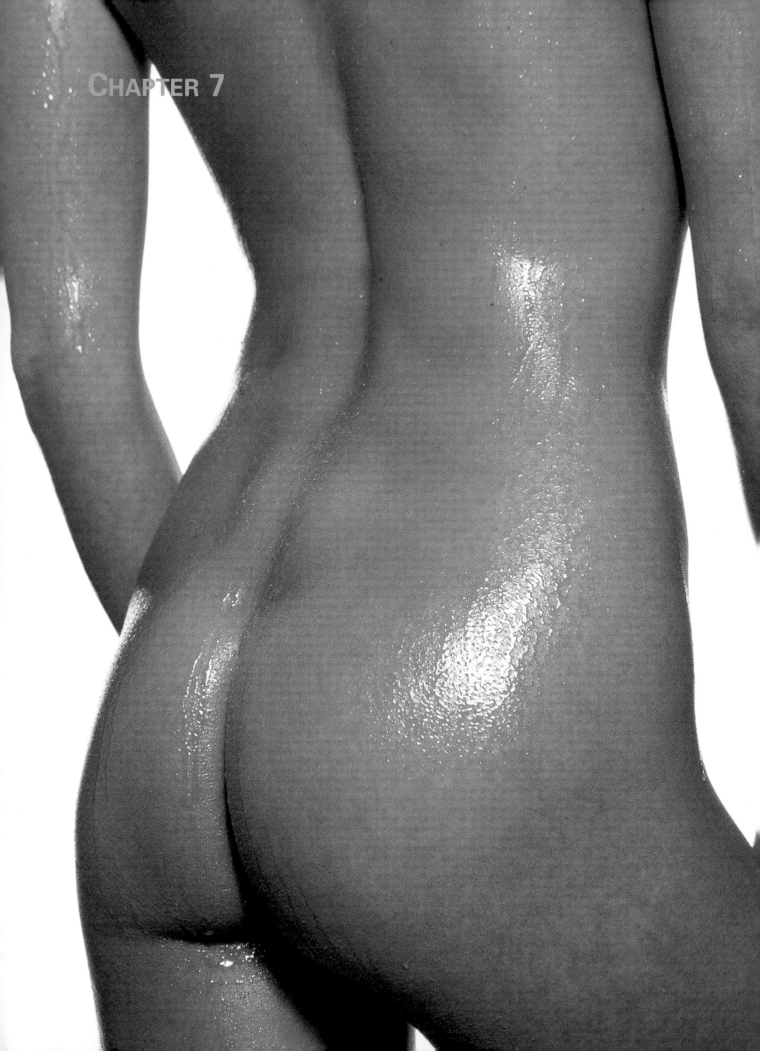

EQUIPMENT

I'm definitely not a tech-head or an equipment junkie, and I certainly don't like carrying around more equipment than I have to. I stick to a basic lighting setup that I know very well—Dyna-Lites with their small, very portable power packs and 35mm equipment I'm very comfortable with. I've shot with Nikons for years, and I currently use F4 and N90 bodies. I'm a big fan of zoom lenses; they're very sharp and eliminate the need to carry around a lot of lenses. ■ I have three 80-200mm zooms, and I use them on location and in the studio. That's the lens I use 90 percent of the time. I might go to the 35-70mm at times, but generally it's the 80-200mm—I can do a lot with that lens. It's like making a movie and getting an establishing shot, a medium shot, and a close-up. With that lens I can photograph a model's entire body, her face, and parts of her body that I isolate. It's great not to have to stop and change lenses or be handed another camera body and lens by an assistant. That can kill the mood of the shoot.

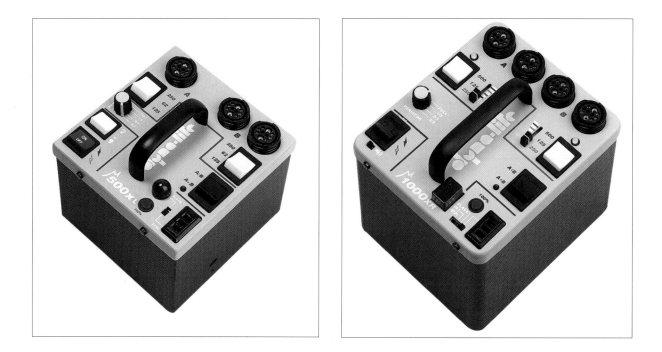

Dyna-Lite's line of "M" series power packs includes two small, very portable units: the M500XL power pack, weighing only 4.2 pounds with 500 watt/seconds of total flash power, and the M1000XR power pack, weighing just 6.7 pounds with 1000 watt/seconds of total flash power. Photographs courtesy of Dyna-Lite, Inc.

Another thing I like about the zoom lens is that the model doesn't necessarily know what I'm photographing. I zoom in and out and make tight face shots and three-quarter shots—the model doesn't have to know what I'm focusing on at that moment. She's free to be into the mood of the shoot without worrying about a particular part of her body. It makes for the best, most expressive photos. And if there's something in the frame I don't like, I can use the zoom to crop it right out. I've had times when the hair and makeup artist arranged the model's hair just a little too high on top—I can adjust the zoom to take care of that.

Although I now use zoom lenses most of the time, I had avoided using them for years. I felt, like a lot of photographers, that they just weren't sharp enough, surely not as sharp as a single-focal-length lens. Then I did a workshop in which one of the participants had an 80-200mm zoom, and he suggested I try it. The results convinced me. Now, with a 16mm or 20mm wide-angle and two zooms—the 35-70mm and the 80-200mm, I have three lenses that cover just about everything I want to shoot.

The camera bodies are all fitted with motor drives so I'm always ready for the next shot, and that's about the only thing I've set for automatic operation. I rarely use the lenses on autofocus—I still like to focus manually. The only time I'll use autofocus is if I'm outdoors and someone is running towards me. I never use auto-exposure, either. Inside I'll take Polaroid test shots to arrive at the f/stop settings, and outdoors I'll take my readings with my flash meter.

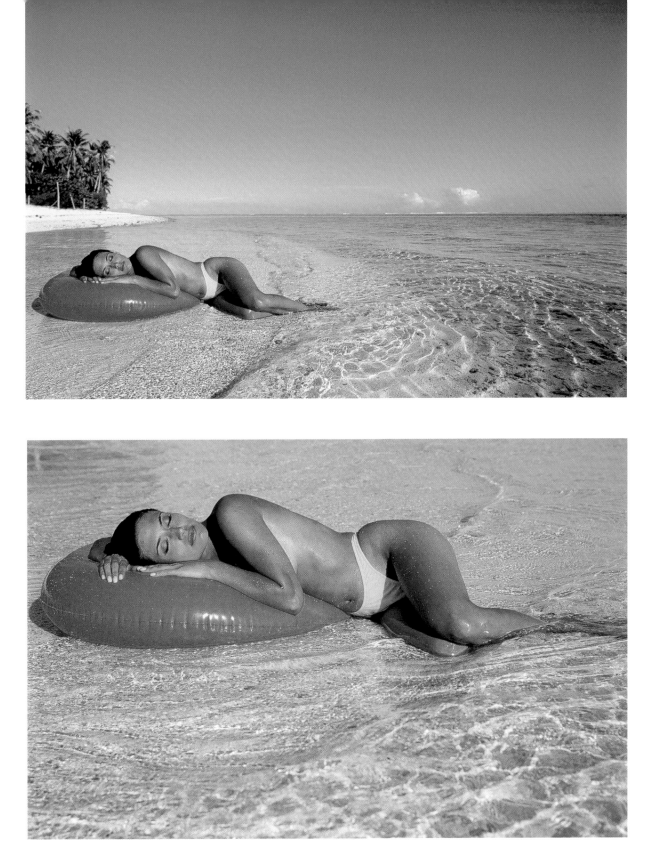

The same pose, but because of framing with the zoom lens, these views of Donna in Bora Bora can be used for very different stock sales: The close view can be used for anything health- or beauty-related, and the longer view, with more atmosphere and location, gives plenty of room for a layout for a resort. Also, with the zoom lens, I didn't have to stop to change lenses and risk disturbing the model's expression.

I have the lighting down to the basics—the Dyna-Lites on booms in the studio are easy to roll into position and easy to roll out of the way. Each light is fitted with a diffuser that I use most of the time; I'll take the diffuser off only when I want the look of a harder light.

I use five basic filters: polarizing, 81A, 81B, a Tiffen 812® warming filter, and a Tiffen Soft/FX® 2 soft-focus filter when I'm photographing nudes. The soft-focus filter adds just a bit of softness—it takes the edges off without adding any blur and tends to tone down the look of makeup, making the models' faces look so much more natural. A soft-focus filter really refines the makeup artist's work. It's such a subtle filter—when you're looking at a chrome, you really can't tell if the filter was used. It's only when you look at a side-by-side comparison, one chrome with and one without the filter, that you notice the difference.

The film I'm using most often these days is KODAK EKTACHROME 100 Professional Film. It gives me very clean, bright whites and crisp colors in or out of the studio. And although I always have tripods around, I'd say that 85 percent of my work is done hand-held. I can handle the 80-200mm zoom at 1/60 second.

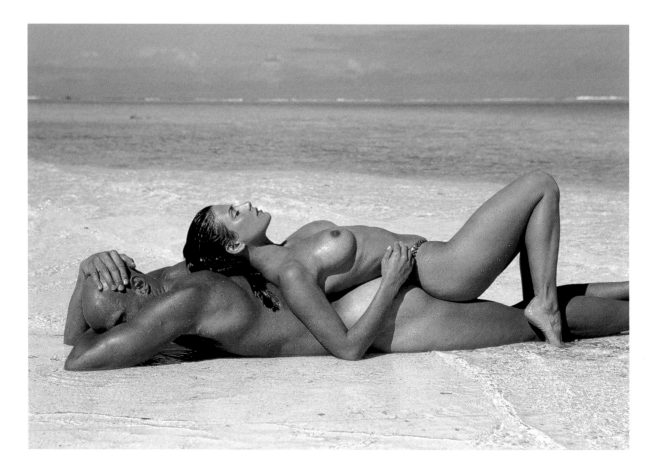

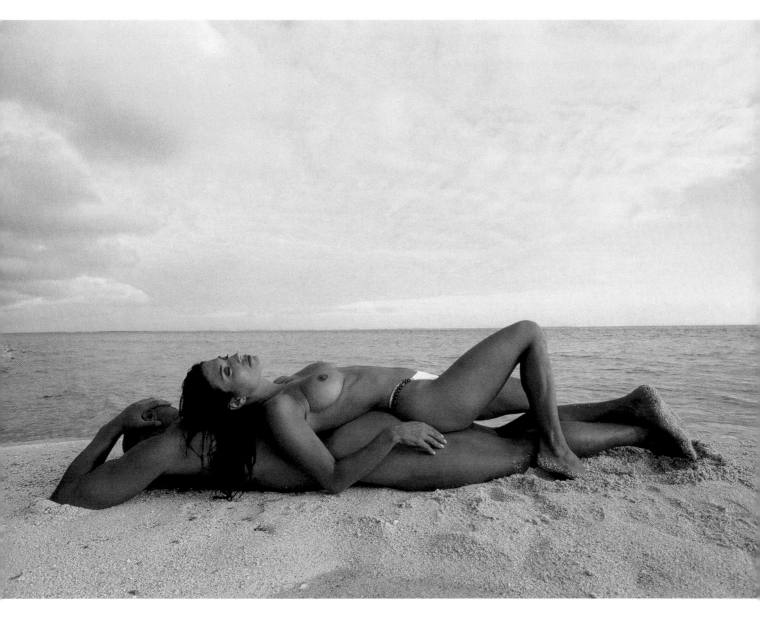

Here are Donna and Michael on location in Bora Bora. I photographed
them first with a polarizing filter (left), and it's a good picture, but then I
put a Tiffen 812® warming filter on (right), and it made the whole scene
so much more dramatic and gave a different dimension to the sky. The
photo above is my favorite photo in the book.

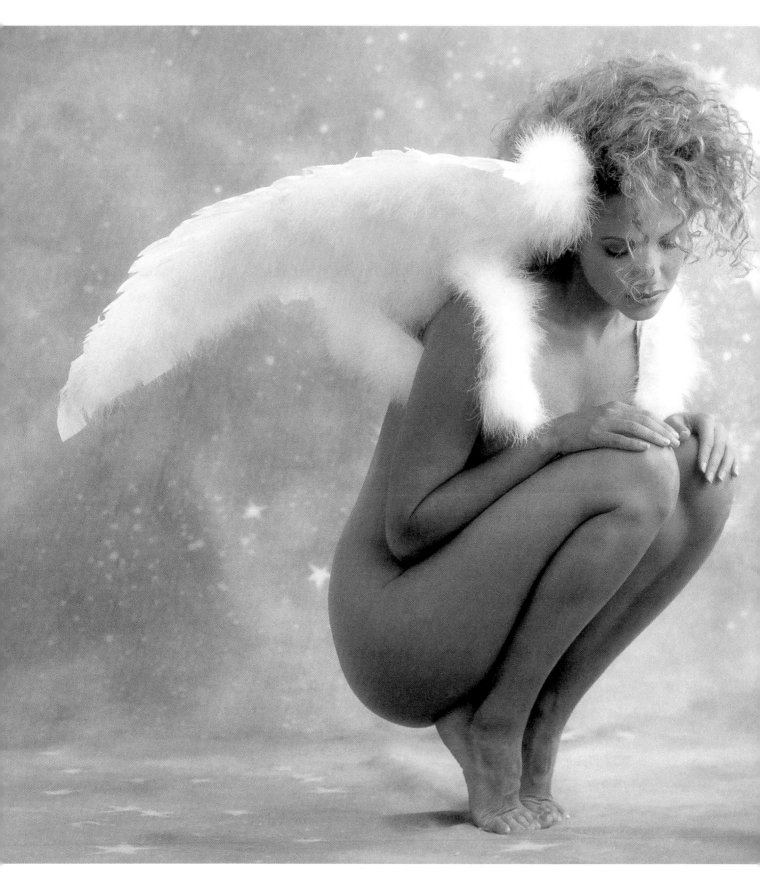

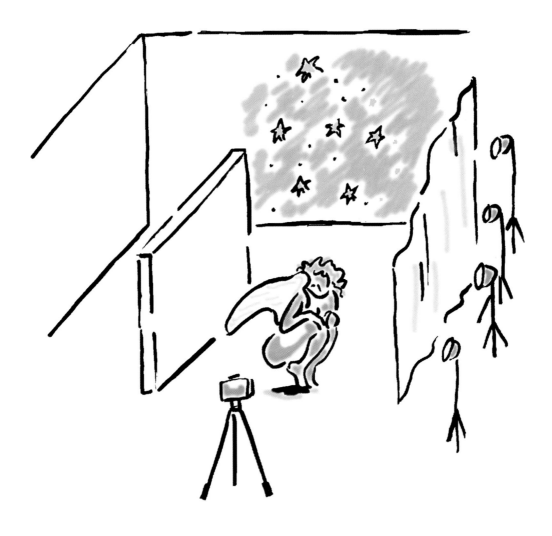

The lighting is kept very soft and simple so it doesn't overwhelm what's interesting in this shot—the wings, the pose, and the background. A parachute diffuses the light from four strobe heads, and a large fill card to the left of the camera bounces light into the shadows.

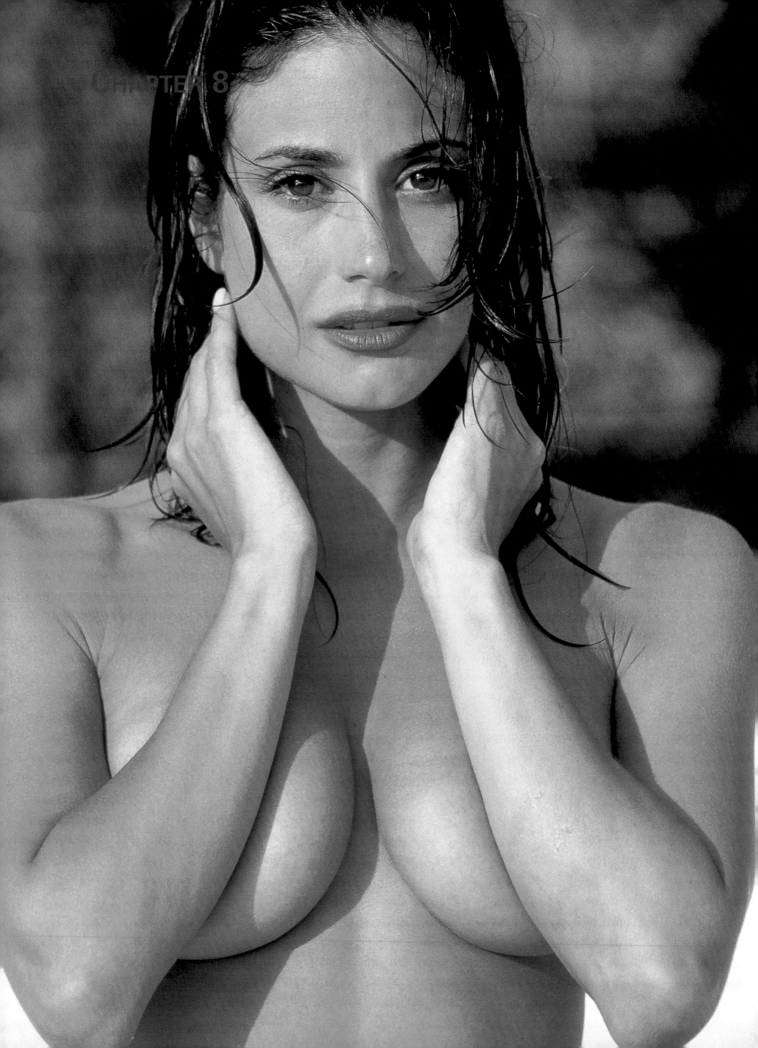

THE BUSINESS

Things change in this business. Tastes change, assignments change, the art directors and photo buyers change. And often photographers have to change their approach. But you don't change your entire style. ■ Talented photographers who have good technique, ideas, and a style are always going to survive. But these days it takes a lot more perseverance to become and stay successful. It's easier to get good photographs today—the equipment is a lot better and, if you like that kind of thing, a lot more automatic. But what people are buying is style and vision. Art directors and picture buyers are always looking for something new or something reborn. A new approach, a new slant, a new face—anything they haven't seen before. For nude and beauty photography, it may simply be the model—that "new face" that's perfect for whatever they have in mind. ■ Most of all, you keep shooting, keep creating new work. You can't send out the same portfolio, the same mailer, and photographs of the same models year after year.

Over the years I've had to change my subjects and even my approach to keep up with what buyers are buying. I don't do the real dreamy, grainy, girls-in-white-dresses-with-umbrellas anymore. Now what I do is more realistic, more catch the moment, catch the laugh, the smile, the jump. We are not into the dreamy world anymore; that look is over...for now.

Art directors are also looking for consistency and reliability—they have to be able to count on the photographers they hire to deliver on time and on budget.

Computers, with their ability to correct and combine images, have changed things. They make it easier for buyers to make new pictures from older ones. But the good photographer with a specialty, a vision, and a style is still going to be in demand. A lot of people can do the manipulating, but when you come down to it, not as many people can make the great images from the start.

Starting out in the business today is, I think, a lot harder. When I began, I could call an art director at an agency and get an appointment to show my book. That's over. There are too many photographers, and art directors don't have the time or patience. You're lucky if you're even invited to drop the book off for a viewing.

Even if photographers could get in to see art directors, who has the time? That's why, for the first time in my life, I have a rep. Before that, I represented myself. I started by calling on magazines. I reasoned that if I got editorial photographs in magazines, my name would be under the photo, and that would be great for getting the next job. And magazines are very apt to use new people. They'll take a chance with someone unknown, whereas an ad agency wants people who are proven. They won't jeopardize a $100,000 account or a $1 million account with somebody that no one has ever heard of. But magazines like new work. They think that new people are more creative. That's ridiculous, but I was certainly willing to take advantage of that kind of thinking when I started.

Of course, I had a bit of an advantage when I started. I'd been a model and knew a lot of people. I'd say, "Hi, this is Nancy Brown, I worked with you on the so-and-so account, and now I'm a photographer." They were probably thinking, "Oh, no," but at the very least they agreed to see me. I got in the door. These days you're lucky to get your book in the door, but anything that opens the door can be beneficial.

But as the years passed, it became very difficult for me to do the photography, keep the studio running, get books and portfolios out, and represent myself to ad agencies and design firms. So I thought, why not have someone working for me whose job it is to cultivate

With the model's hair back, head up, and graceful positioning of her hands, this is the kind of nude photo that can be used in beauty and cosmetic ads for a number of products.

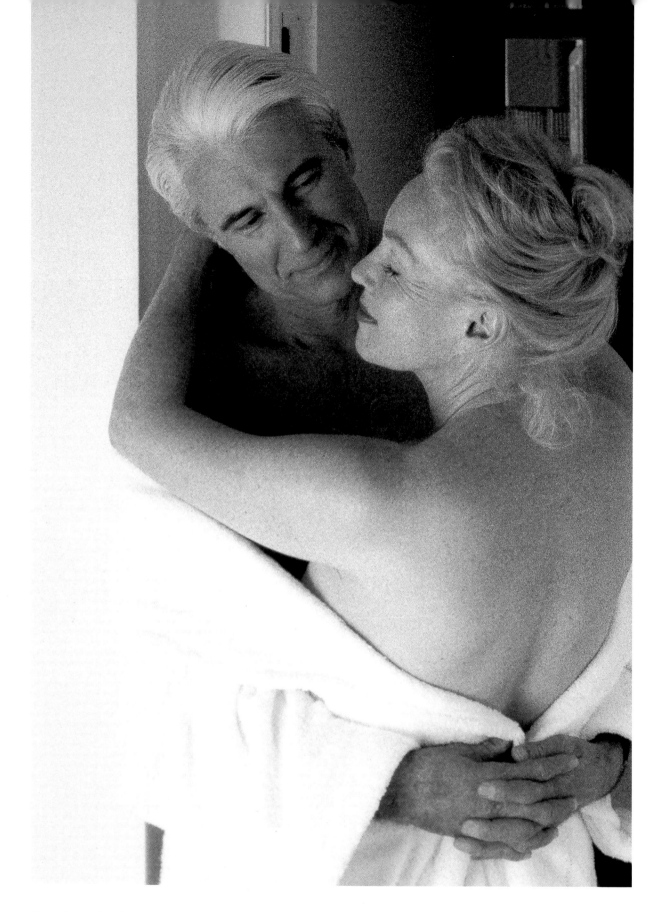

I used a grainy film for this photo, which I thought would be more flattering to this couple. I think the photo has a nice warm feeling. This model had wanted some new photos for her portfolio; she knew exactly the kind of pose she wanted.

the ad agencies? That's exactly what my rep has been doing, and I'm getting very good results. I've learned that there's a need and a desire for the clean, direct style of my work.

My rep also handles five other photographers, but since we all have different styles, approaches, and specialties, there's no conflict. One of the photographers shoots still lifes; one shoots mainly men; I do beauty, women, and lifestyle; another specializes in corporate photography; and another does only portraits. That's one way in which the business has changed: Years ago a rep might successfully represent only one photographer. These days reps will have a stable of photographers, and they can cover most clients' needs without overlapping.

It's not easy to get a rep. There are lots of photographers out there, and reps can't handle every one of them. If you're new to the business, you won't get a big-name rep until you have a substantial book and some clients. My rep is a former model—that's how I knew him. He has a great personality, and he really knows the business. For a photographer just starting out, I'd suggest representing yourself. Take the time and make the effort. Get your book together, try to make appointments, try to see people. Then at the very least, you'll know what it's like. You'll know what reps are up against, and you won't have the unrealistic expectation that a rep is going to bring you jobs right away. So far my rep has gotten me a couple of good jobs. Things are happening, but I know it takes time. It is a tough business.

If you can't do it yourself, the tried and true method is to have a friend or your spouse make the phone calls, get the appointments, and show people your work.

When you do get a rep, be prepared to pay at least 25 percent; the big-name reps get 30 percent, but if you're hooking up with one of those, you're probably doing well enough that the extra five percent isn't an issue.

Sometimes it just comes down to luck and timing—just having your book in the right place at the right time, in the hands of the art director who's looking for the kind of work you do. No matter how hard it is, though, I'll guarantee one thing: Art directors will remember you if you have good work. If you leave good promotional pieces and send promotional updates on your work, they'll think of you when the right job comes up. Otherwise, how is anyone going to know what you're doing?

I'd suggest having a book for every specialty—like lifestyle, beauty, and fashion—three or four copies of each book. It never fails—you get two calls on the same day for the same book, so you have to have enough to go around. I have a "child" book, a travel book, and several different lifestyle/beauty books.

My books change all the time. I use 70mm transparencies mounted in frames, and I keep them in a cabinet: a box of images of children, one of travel, two of beauty and lifestyle. When someone calls for a book and says, "I'm looking for an image of a couple," I'll load the book with couples. I can change the book instantly—add more beauty, more children, more men.

Of course, these days the Internet plays a part in everything. If you're a photographer, you have to have a Web site so you or your rep can say to an art director, "Sure, we'll send the book right over, but in the meantime, you can take a look at some current work on the Web site." I've had my site for about three years, and it works. I get e-mail and telephone inquiries. I've sold some photos, but so far I don't think the site has led to an assignment. But the most important thing about it is I'm able to say, "You can see more of my work on my Web site." At the very least, I know it's gotten me workshop participation. People see the work and want to learn more about how I create it.

In addition to a rep, portfolios, and the Internet, I also use the professional directories, the so-called showcase books. I'm always in *The Gold Book*, which is distributed all over the world but has a lot of emphasis in the New York City area; it also has a big Web site. It has big pages, good color presentation, is reasonably priced, and I can get an extra print run of my pages that I can use for my own promotions. For me, to be in a book that goes all over the world and to get, say, 2,000 copies of my pages is very worthwhile.

One thing you have to realize about the source books—you can't expect immediate, unbelievable results. You might get a call for your portfolio from a source book that you were in three years ago. And you will sell pictures from your pages, but not necessarily in the year those pictures appeared—it might take two or three years. But every year the buyers look, and every year that they see you is another reminder of what you can do.

My promotions don't include mailers—I don't think they're worthwhile. I know a lot of photographers like them, but I prefer using my promotional pieces as leave-behinds when my rep calls on a buyer. I use them at my workshops, too, and include them whenever I send out the portfolio. But I don't use them for cold mailings.

It has been said that most success in life comes from just showing up. Be there. I have, for over 25 years. In showcase books, in promotions, and now on the Web.

Lisa wanted a shot that showed her face, skin, arms, hands, and feet without being totally nude. I love this photo with her hair pulled back. It gives the whole photograph such a clean, neat look. I've used this photo for one of my promotional pieces.

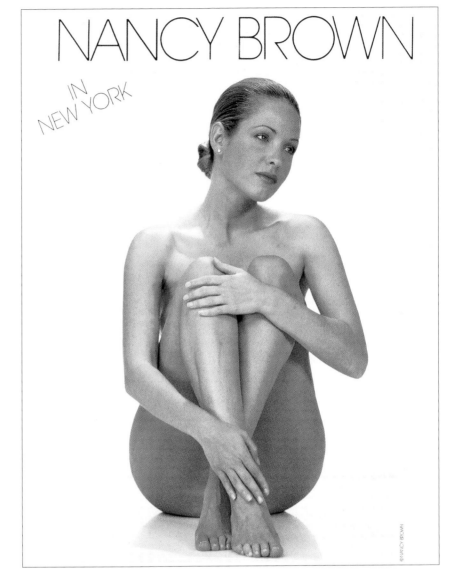

NANCY BROWN

IN NEW YORK

Setting Prices

No matter what you're shooting or where you're promoting it, you have to know what it's worth. It's one of the biggest concerns of photographers: What do I charge?

I base just about everything on usage. Is the photo for an ad in a national magazine or for a local public relations effort? Is it for a point-of-purchase display in a chain store or for a statewide billboard? Your photo is worth a lot more if it's on a billboard than if it's on the inside back cover of a trade magazine.

Day rates for photographers can vary according to how big their reputations are or in what city they work, but the first thing to consider is how the photo is going to be used. Then I'd adjust the fee based on the degree of difficulty of the shot. The photo may be for a trade ad, but if the shoot is going to be difficult, I might charge as much as I would for a consumer ad. Always figure use, time, creativity, difficulty.

Where do photographers get the use figures? I use a software program called FotoQuote, by Cradoc, as a guide. There are also lots of guidebooks available, and the professional organizations, like PPA (Professional Photographers of America) and ASMP (American Society of Media Photographers), help their members price their work.

When you work with a stock agency, it's easier—they set the prices. You get your percentage and that's it.

Model Releases

Another important business consideration is the model release. It's fundamental—get everything released in writing. There are a number of standard releases used. ASMP has one that's in widespread use. And you can modify the release to suit the circumstances. The releases I use are basically "buy-out" releases. I'm paying for all use of the photographs. I explain to my models that when I do stock photography, I can't predict where the sales are going to come from. I don't want any problems later, so the models have to know that the pictures could appear anywhere.

For nude photographs, however, I use restrictive releases. I have to know where the photos are going to be used, then I ask the model and get her okay. It's not a special release, we just add a line: "must be approved." In those instances, the stock agency must notify me and cannot use the image unless I get the model's permission. I don't want my photos turning up on X-rated Internet sites.

And I often do something extra for my models. Most stock sales don't bring in that much money, and the only money the model gets is the initial modeling fee. But in the case of a windfall, say a nude or beauty shot that brings in a few thousand dollars for an ad, I'll give the model ten percent of the sale.

An important part of my business for several years has been my workshops. Typically I'll conduct three three-day workshops a year, in my studio, for six participants. I'll have models and makeup and hair artists, and we'll often do a day's location work as well. Expenses are pretty high, so the fees are, too, but participants get a lot out of it. It's practically one-on-one instruction, and with only six people, I'm able to tailor the days to whatever they want to learn.

Ultimately, the thing that beginning photographers must know is that photography is a business. You can learn that in school or as an assistant, but you have to learn it. You're selling a product, surely one that can be exciting to create, but a product nonetheless.

When I'm not on location, this is where it all happens—at my studio. When this was taken, I was giving a workshop on beauty and nude photography. Nothing's posed—it's all going on at once. A photographer friend, Matt Proulx, took this from the upper deck of the studio.

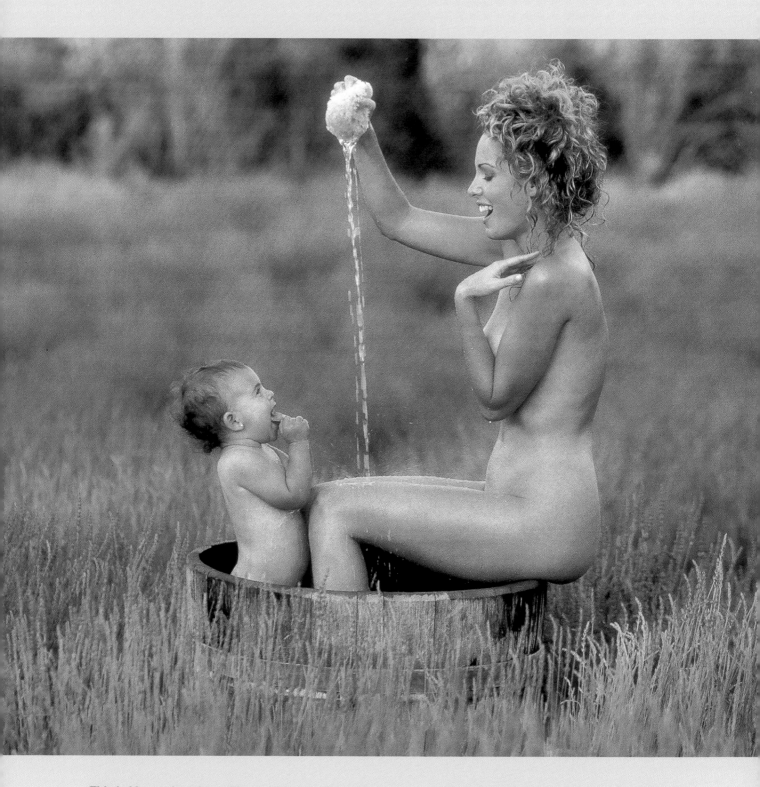

This is Lisa on location with me in France. The child is the makeup artist's baby. Lisa said she wanted to do something in a lavender field and luckily we found one. I've used this photo for a promotional piece and, of course, sold it through the stock agency. It covers a lot of bases: beauty, a family-type situation, and almost anything for young children. The little girl was very cold, but she didn't want to get out of that tub! I took this in the evening—it was late, but we still had great light to work with.

Working Stock
A Talk with The Stock Market's Richard Steedman and Sarina Nameri

A lot of the photography I do is for stock, and stock sells. I'd guess that 80 percent of the photographs used in magazine ads are stock images. And because there's so much stock out there, you have to produce good work if you want to shoot for stock and survive in this highly competitive market.

For the photographer, shooting stock is an investment. I'll get a want list from my agency, The Stock Market, or I'll come up with my own ideas and shoot the pictures. But I may not see any return on that work for many months, maybe years, as the images make their way into the agency's catalog. Meantime, I've had to hire the models, set up in the studio or travel to the locations, and process the film. Because of that, it's really important to get not only stock shots from my shooting day, but also some good work for my portfolio.

Considering the importance of stock, this book's editors spoke with The Stock Market's president, Richard Steedman, and with Sarina Nameri, a photo editor at The Stock Market.
—Nancy Brown

Richard Steedman, President, The Stock Market
"Our want lists come from our experience in the market. After you've licensed some $60 million in photography over 18 years, you tend to understand what the market is asking for; we determine the trends, not only to be sure we're keeping up but also to try to anticipate what the next moves will be in the creative community.

"We analyze all of the current magazines—in fact, we spend about $500 a month on magazines. We analyze the pictures, we tear them out, we keep them in a huge tear sheet file. We note what's going on, like people using a lot of black and white and that there are a lot of shots with the moon in them. We also notice the kinds of lighting, the angles, and the techniques photographers are using and clients are buying.

"In this respect, we actually act like a client. A modern stock agency really puts itself in the position of being the phantom client for the photographer, helping to assign and, in a sense, create the work that eventually ends up in ads. It's just as if a creative director had assigned the shots.

"We analyze tear sheets not just from America, but from Europe, too—from France, Germany, England—and we look for the trends there. In some ways, the foreign magazines are ahead of the United States. They can be a little edgier, because they don't have as much focus testing, meaning the image isn't as tied to the product as it is in America. There is a degree of caution in the United States, because clients feel the necessity of not offending people and of keeping within certain taste boundaries. Quite honestly, European images can be much more 'out there.'

"The 'want list' that we produce and send out to photographers through our newsletters is a general list: we need couples, we need business people. What really happens within our agency is that the details are covered on a one-to-one basis when we talk to the photographers.

"We understand and appreciate that each photographer will have a different way of approaching the subject; each likes to work in a certain way. We try to tailor our comments to the photographer's talent and shooting style. So there's a lot of one-on-one between the photographer and the photo editor. That's where we get specific, where we actually sit down with the photographer, or if we can't do that, we have long phone conversations. We have samples of tear sheets to show the styles and moods we're interested in. We discuss things in great detail, just as an art director or client would with a photographer in a preproduction meeting. We contribute our thoughts, what we think the photographs should look like, what the action should be. And we want the photographer's input. Our photographers are encouraged to come up with their own scenarios, because we need their talent and contribution.

"It's a great responsibility for us. Photographers have to spend a considerable amount of money on their own as an investment to produce this material, so we want to be able to give them the very best shot at it and protect their investment. We want them to produce work that's going to sell.

"While we tailor suggestions to our photographers' particular strengths and often move them in certain directions, I think it's wrong to overdirect a photographer. Our position here is to never turn photographers into factories; it's destructive and counterproductive. What we like to do is discuss it with them, get them excited about something, and let them fill in the details. I don't want to fully hammer out an entire scenario and then have someone slavishly go about producing it. We try to attract the kind of photographers who will take a direction and then add their spin on it.

"Nancy is pretty much her own boss. During my photographic career, I used Nancy as a model, so we go back a long way. She always has a firm sense of how and where to do the job, and we don't have to tell her a lot. Obviously, she likes to do beauty, health-related subjects, cosmetics—pretty things. So we base our comments along those lines. It's wrong to try to force photographers to do things that are not pleasing to them.

"Our strength is 'live stock'—images with people. A lot of what the photographer achieves is dependent on casting, especially casting people who reflect the values that advertisers

Our shoot in Bora Bora produced a lot of great stock photos. Here's Donna in an outdoor shower; I got down on the deck next to her for the shot. Backlighting gives the picture its sparkle, and I used a slow shutter speed to streak the water.

believe will attract customers. Nancy knows how to do that, but we might help somewhat in critiquing the models. Overall Nancy needs less hand-holding than a lot of other photographers who have never been through the agency or modeling business. She's been there with art directors and on assignments where product is involved. She is very observant.

"In addition to direction, what all photographers need from their stock agencies is encouragement. Photographers like applause, it's as simple as that. We give that applause and also constructive critiques. In Nancy's case, because she's been in the fashion business for a long time, we might say, 'It's too much of a fashion picture. The models need to be more the couple next door rather than the couple in *Vogue*.' That would be something that is important to communicate, because she comes from a high-fashion background.

"Nude and beauty photography is something that Nancy likes to do, which is very useful for us. I would wish it on all photographers to have an area, a specialty, that they like to do. When that happens, it makes for better photographers. You can always tell from the picture that the photographer likes to do this type of work; the pictures take on an excitement for the viewer. You can definitely read when the photographer is having a good time, and that's important, because

It's best for a photographer to have a specialty, an area of photography that he or she especially enjoys, like in this case, nude and beauty photography.

it's the photographer's enthusiasm that makes that photograph sing and makes people relate to it.

"Those are the people we want to work with—the ones who enjoy the job. And it's our job as an agent to get people really excited about what they're doing. We say, 'It's nice to make a lot of money, but it's also nice to feel that you created a really good, interesting piece of work.' That's tremendously important for the longevity of the photographer's career.

"Strangely enough, I think someone starting out today in stock photography is going to find things more open than ever—*if* that person is ambitious. It all depends on how hard you try. First of all, you have to have some degree of talent, but you also have to have taste. Taste is so important. Sure, people can learn to mimic it, to fake it to some degree. But if you take somebody who likes art, goes to museums, listens to music, is interested in style, and is curious about the world, somebody who has a certain graceful relationship with the world and its beauty, when that person picks up a camera, the photographs are going to be natural extensions of his or her taste and interests.

"People starting out in stock often begin by photographing children, simply because it's hard to make many mistakes shooting children. Children are little theatrical geniuses. If you watch them long enough, they come up with these unbelievable little scenarios. They tire easily, but for a few moments, they are precious. So you start by capturing those moments.

"While you have to get the fundamentals correct—the exposure, the lighting—that's not what stock photography is all about. What our business is really about is understanding human nature and capturing it on film. Especially today. We prize a certain kind of wonderful innocence in photography, even if it was derived in a complex way. There is a certain interest in the snapshot. We have actually brought in housewives, insurance agents, salesmen—people who have a creative eye and just want to change their life. And we coach them. They become interpreters of life—our business is about communication, about creating something that quickly and directly communicates a mood and a spirit to someone else. Photography schools are not a good background for this. Life is a good background for this."

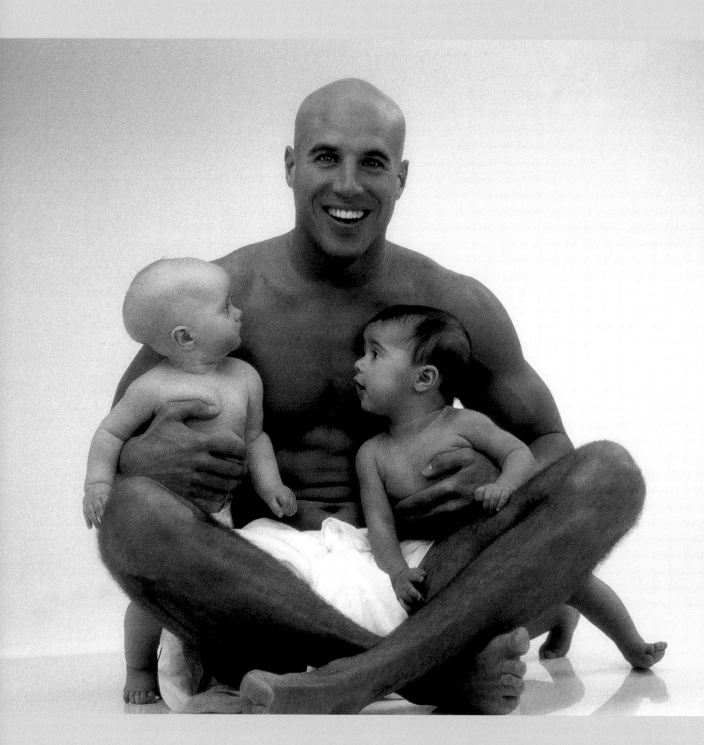

It's hard to make many mistakes photographing children; they are little theatrical geniuses. If you watch them long enough, they can come up with unbelievable little scenarios.

Here the emphasis is on fun, with a lot of skin to light! Lighting on Michael and the babies is a strobe with a pan reflector mounted on an extension arm over the camera. It casts soft, even illumination over the scene. Foamcore flats bounce light onto the subjects and fill the shadows. The background is a simple white seamless illuminated with three lights; an HMI strobe clamped to a crossbar provides light from above, and 2000 w/s Fresnel strobes are positioned on either side of the set.

Sarina Nameri, Photo Editor, The Stock Market

"When we work with our photographers, we'll often suggest very specific things for the models to be doing, because there are things we know our clients are asking for or things we have seen sell over and over again. Sometimes they're simple things, like running on the beach, that sort of thing. If you have a beautiful woman you can do that. But then you can take it in another direction and throw in a cell phone or a laptop, which takes it away from being strictly a beauty shot and now opens up a different market for the photo. You shoot it both ways, work in both real-life and slightly fanciful situations.

"If our lists are calling for beauty treatments or, say, 'a day at the spa,' I automatically think of Nancy—she's our beauty photographer. I would give her a call and see if she's interested in doing this kind of assignment, and we'd talk over how it would be executed. It's the same thing with her travel work. When she was planning to shoot in the Bahamas, she called to get my opinion on what type of models she should have. I spoke with my director of photography, and we came up with one senior lady, one Caucasian athletic type in her twenties, and either one African-American or Latin model in her thirties.

"Sometimes a photographer will call looking for input on where to go, what area of the world would be workable. Or a photographer will want to talk about what we might need from a shoot that's going on right at the moment. A few weeks ago, Nancy called and said that she had a model in the studio who had gorgeous long hair. Was there anything specific I needed or would like to suggest as a possibility? I told her to have the model spin around so she could capture the motion of her hair. She did that, and she also put flowers in the woman's hair; it was actually quite beautiful. We get very specific about an aspect of a model's look, like someone with a great mouth or beautiful eyes. There are so many things you can do with that, and since we don't know what the picture could ultimately be used for, we try to cover a lot of situations.

"It's not like working for a magazine such as *Mirabella* or *Vogue* when a photographer is told, 'We're doing this story this month, and we want you to shoot it; it will look this way, and the art director is going to be there to supervise.' Our photographers submit photographs that can be sold in a lot of different venues, including magazine advertising. They

want to know not only what we think looks good, but also what's selling. And it's our business to know that.

"Because we tend to keep the guidelines simple, we like to work with people who are smart, people who are thinkers, who understand what we're saying and who can also create on their own from their own observations and tastes.

"For photographers looking to establish a relationship with us, we ask for an initial submission of about 250 images, and they all have to be pretty good.

"I think a young photographer should, in the beginning, concentrate on one area—whether it's travel, beauty, communications, lifestyle—and get really good at what they're doing in that area.

"Persistence and intelligence definitely make a difference. If I have a photographer calling me for ideas or bouncing good ideas back and forth, that's the type of photographer who will probably be successful in this market."

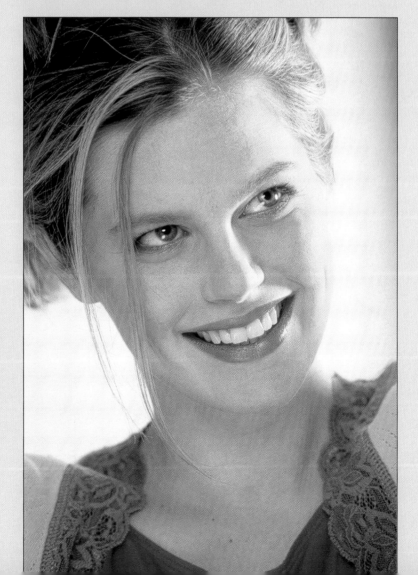

This photo can be used in a number of different ways. The actress I was photographing was noticeably shy and self-conscious. All day she never really looked directly into the camera. So I had her laughing and eating apples to try to relax her. What resulted is a look that is natural, not posed. With her expression, the photo is able to "catch the moment" rather than control it.

This photograph is the opposite of my usual clean look. It's been used several times, obviously for stories about health spas and the benefits of mudpack treatments.

We built a small set in the studio and lit it very evenly with three strobe heads positioned to the left of the camera. A parachute acts like a giant softbox and diffuses the light. A large fill card positioned to the right of the camera just outside the frame reflects light onto the model, Caroline. The background is sheet linoleum supported by several flats.

For stock shots, a flower always helps. Put in a flower, and a picture becomes more saleable.

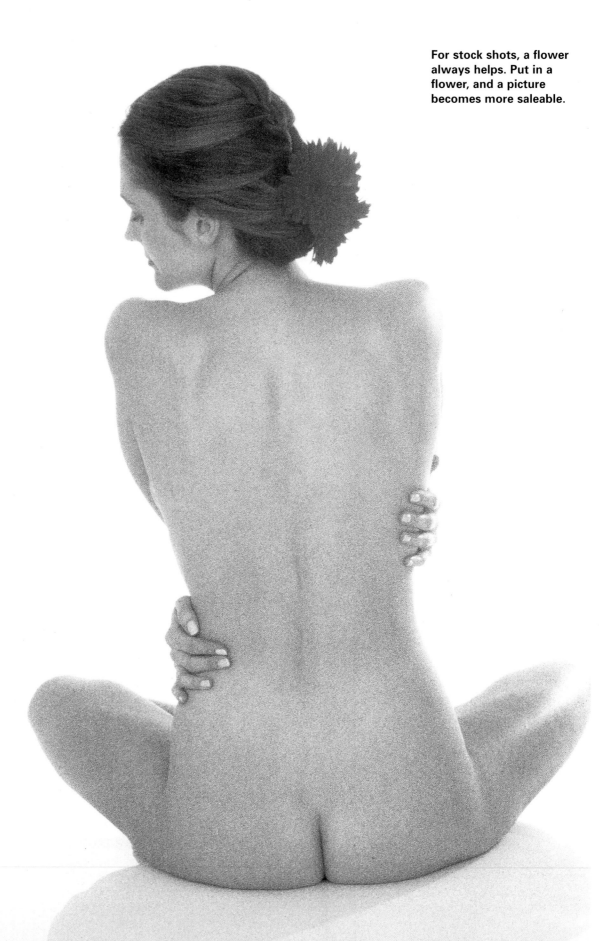